IMAGES
of America

ROCHESTER'S HISTORIC
EAST AVENUE DISTRICT

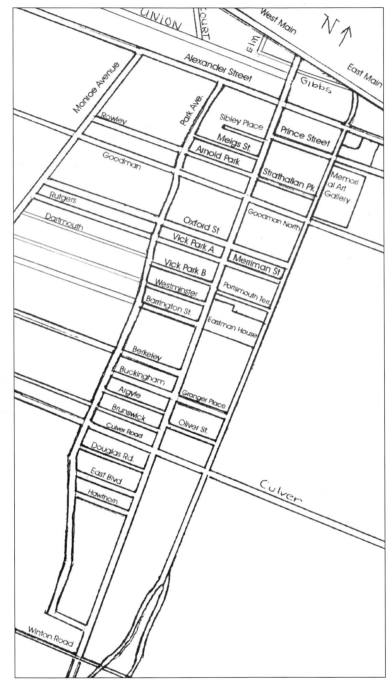

The boundaries of preservation districts vary depending on whether it is a local, state, or federal designation. It can get complicated. We, however, will proceed on a journey unencumbered by bureaucracy. The residential area between Culver and Alexander holds the most fascination. It was here that many of Rochester's industrial captains built their mansions and planned great private and civic enterprises that continue to benefit the county. Along our journey, we will take diversions to places that may not lie wholly within this district or that district but are irresistible and significant to our story and so must be explored.

IMAGES
of America
ROCHESTER'S HISTORIC
EAST AVENUE DISTRICT

Michael Leavy

ARCADIA

First published 2003

Published by Arcadia Publishing,
an imprint of Tempus Publishing Inc.
Portsmouth NH, Charleston SC, Chicago,
San Francisco

Printed in Great Britain

Library of Congress Catalog Card Number: 2003115048

For all general information, contact Arcadia Publishing:
Telephone 843-853-2070
Fax 843-853-0044
E-mail sales@arcadiapublishing.com
For customer service and orders:
Toll-free 1-888-313-2665

Visit us on the Internet at www.arcadiapublishing.com

This is for Francis Leavy, Daniel Needler, and Richard Phalen.

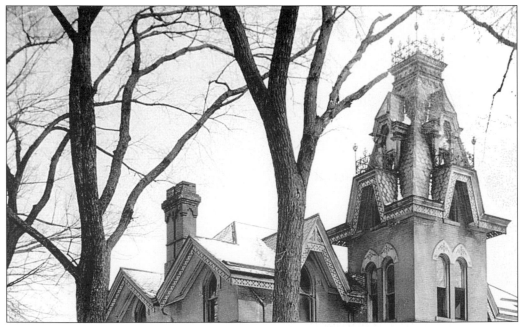

Shown are roof details of the Meyer residence, which stood at 268 East Avenue.

CONTENTS

ACKNOWLEDGMENTS

The written sources used for this book are *The Grand American Avenue*, edited by Jan Cigliano and Sarah Bradford Landau, and *East Avenue's Turbulent History*, by Blake McKelvey, in Volume XXXIII Rochester Public Library 1966 edition of Rochester History publications. Special thanks go to Cynthia Howk, architectural research coordinator for the Landmark Society of Western New York.

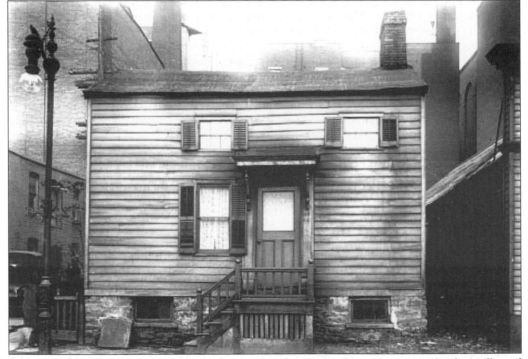

A small home representative of the early east-side dwellings of our pioneers is slowly swallowed by an ever growing Rochester. This home may have been located on Elm Street.

INTRODUCTION

When Josiah W. Bissell failed in the early 1840s to persuade the Rochester Common Council to change the name of East Main Street to East Avenue, he took matters in his own hands. With a hammer, nails, and wooden signs, he set about affixing the name East Avenue to all corners from the Liberty Pole to the city line. As for the homes along the northern end, sanitary conditions were rather crude. One resident later recalled, "Every house had its cesspool which seemed to collect and retain, rather than remove, the refuse matter committed to it." The Erie Canal, a short distance away, was also rife with contagion because of its lack of current. Bissell, however, believed in the avenue and continued his own improvements, such as planting horse chestnut trees along both sides. He then obtained ordinances for crushed stone paving and the use of omnibuses for public conveyance.

In 1853, Azariah Boody offered some of his land nearby for a new University of Rochester campus. Officials were polite but cast a dissenting eye upon the prospect. It seemed unlikely that students would want to travel "away out in the country" for an education. In spite of some of Bissell's improvements, East Avenue had not developed much from the crudely hacked road pioneers used in the early 1800s. It had a vast and miserable swamp that was useful only in winter for ice-skating and sleigh racing. However, the nucleus of a fashionable social colony had already been established in the 1840s in the form of three elegant mansions built for William Pitkin, Aaron Erickson, and Silas O. Smith.

Boody's offer was eventually accepted with an option for an additional 17 acres for future expansion of the campus. Developers were fast upon the new sight, and residential side streets were soon being laid out. They contained fashionable homes, for the most part. Shortly thereafter, the intellectual and social center of the city was supplanted to this new colony, having been wrested from the Third Ward on the west side of the river. The swamp was drained, and the affluent of Col. Nathaniel Rochester's mill town began putting up majestic mansions along the avenue.

Rochester was much like a traditional New England port town, with residential streets around the commerce centers of harbors. In Rochester, that was the Third Ward near the Genesee River and Erie Canal. It was simply easier to walk to work than to ride in from elsewhere. Improving transportation, however, was changing that.

In 1866, James Vick, a successful seedsman, acquired the Old Union Tavern and Race Course, at the corner of what is now East Avenue and Vick Park A. He cultivated a nursery of blooming bulbs and shrubbery so beautiful that Rochesterians took country rides to visit the gardens. The tradition of Rochester as "the Flour City" was already changing to "the Flower City." Vick, gambling that he could attract citizens to live out there, converted his racecourse to a residential park. His risk paid off, making him the proud overseer of Rochester's newest and most fashionable neighborhood. Soon, nearby seedsmen began converting their nurseries into residential streets. This occurred when American cities and towns were becoming fascinated with the concept of grand boulevards, where the new robber barons could showcase their wealth with majestic mansions. The era, beginning in the 1850s, took off in earnest after the Civil War, when dynamic social and economic forces transformed American cities. The era lasted well into the 1920s. It is interesting to note that Rochester had an eye on a grand approach in the 1840s, before the craze took off across the country.

When George Eastman chose East Avenue for his new residence in 1906, he established it as the principal neighborhood for the city's social hierarchy, an honor long held by the Third Ward. His interest in photography, motion pictures, and science brought many of the world's most influential figures to his address. The mansions went up fast and were so impressive that

many regular citizens felt intimidated. There was a "look but stay away" atmosphere to them. Ironically, the owners of those mansions were less inclined toward the provincial snobbishness of Third Warders. Actually, they were progressive, open minded, and less encumbered by Victorian traditions; they were forward thinking and more responsive to minority and religious considerations. In fairness, many believe those attributes were implanted by East Avenue's Third Ward ancestry.

In the 1960s, the avenue faced the same destructive forces that nearly destroyed the Third Ward, primarily urban renewal. The homes were too large for single families. Plans were hatched—one more horrible than the next, including bulldozing the whole prestigious neighborhood to put in strip malls. There was even talk of routing the inner loop through the main residential district. Miraculously, indecision and confusion over what to do with the decaying neighborhood resulted in a pause in action, giving the Landmark Society of Western New York and neighborhood groups time to mobilize to save the area. Another force that saved the avenue was the activism of Elizabeth Holahan. She had been fairly successful with saving parts of the Third Ward. When it came to East Avenue, she dug her heels in. This time, she had important people with money ready to fight with her.

East Avenue is one of the grandest entries to any city on earth. Its eight-mile length starts in Pittsford and continues to the Liberty Pole on Rochester's East Main Street. A sense of majesty and empire continues to greet (and awe) today's traveler, especially since few of these grand boulevards have survived intact. Spacious lawns, spectacular gardens, old trees, country clubs, colleges, and museums combine in an endlessly fascinating visual journey that echoes the numerous successes of individual Rochesterians. As an architectural mecca, it features masterworks by Claude Bragdon, Harvey Ellis, A.J. Warner, and Frank Lloyd Wright. Dignified Gothic entrances, especially when viewed through lilacs and dogwoods, evoke romantic visions of England.

In 1969, the East Avenue Preservation District was created to preserve the district's legacy. It includes the Park Avenue neighborhood, which has become one of the most appealing places to live in the county. Its many shops, galleries, bakeries, restaurants, and high-end apartments have made it a local version of Greenwich Village. Also included in this book are the University Avenue arts district and the former University of Rochester campus.

This book blends the traditions, legends, and important accomplishments of this prestigious area. As Rochester's showplace, East Avenue is also a pathway through history. It was home to inventors and industrialists who changed lives around the world. They were shoulder to shoulder with the robber barons of their day, but instead of building mansions in Newport or Europe, they invested their money in their city. The spirit of noble philanthropy that animated the area's grand avenue survives as a blueprint for today's most successful citizens.

It should become evident why East Avenue is considered—historically, visually, and emotionally—one of the most spectacular features of Monroe County, if not all of western New York.

One

THE BEST ADDRESS

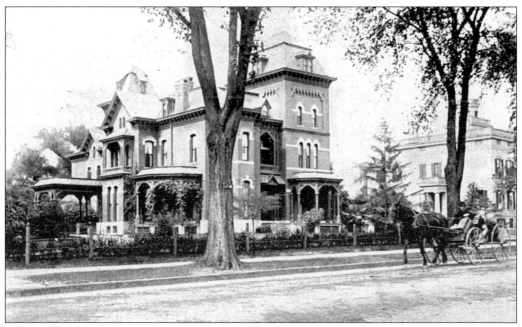

Rochester, like most American cities, underwent dramatic changes during the late 19th and early 20th centuries. Social, economic, and industrial forces brought sweeping changes to this already thriving community, and Rochester would ultimately have more patents than any other city. Rochester's "industrial captains" thus began transforming business and residential streets into some of the most spectacular in the western world. The home of Dr. and Mrs. Ely Smith, pictured in 1890, was typical of the opulent mansions that sprang up along East Avenue. Ely Smith was a physician at Rochester City Hospital from 1868 to 1911. The grand avenue of any city was usually regarded as the best address.

The Bloss Tavern, established by William and Mary Bloss, stood in East Avenue near the Erie Canal in old Brighton Village. Bloss became active in the temperance movement and once poured his inventory of spirits into the canal. He often turned piteous eyes toward the fallen, particularly prisoners, and as a member of the New York State Assembly, he worked to improve jail conditions. He was an active abolitionist, and his house and tavern were a stop on the Underground Railroad.

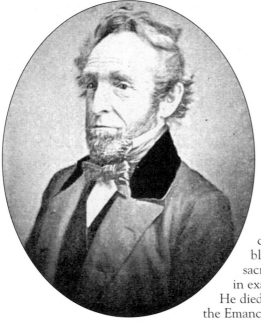

William Clough Bloss, proprietor of the Bloss Tavern, was married to Mary B. Blossom. William was often found at the Reynolds Arcade, advocating for social improvements such as extending the right to vote to women. A full-fledged abolitionist, he once stood up in church and moved over to the side reserved for blacks, where he insisted on receiving the sacraments with them. In the 1850s, he predicted in exacting detail the horrors of a possible civil war. He died in 1863, six months before Lincoln presented the Emancipation Proclamation.

This *c.* 1860 image of the Old Union Tavern gives the best view of what the avenue looked like in its more rural days. The tavern stood on what is now the corner of East Avenue and Vick Park A. It was a famous hotel for many arriving by stagecoach because of its adjacent Union Race Course. Both properties were acquired by seedsman James Vick in 1866. When the University of Rochester moved to a nearby location, Vick took a risk and developed the racecourse into a fashionable residential park known as Vick Park A and Vick Park B.

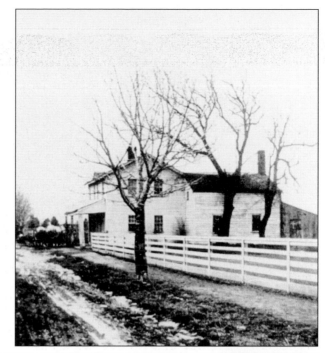

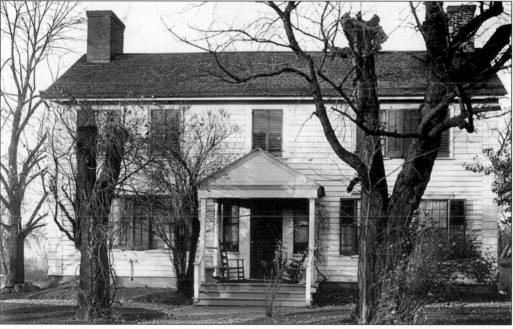

Workers blazed a road from Orringh Stone's Tavern in Brighton westward to the Genesee Falls in 1811. That road remains the original course of East Avenue, although at the time it was actually considered Main Street. Brighton, on the east side of the river, was its own place before being annexed later by a growing Rochester. The few pioneer farmhouses built along such rustic roads usually served as taverns as well. The *c.* 1792 tavern is pictured here as a residence in the 1920s. It would undergo a major restoration in the 1960s. The interior retains its original wide-plank floors and cooking hearth. (Courtesy Irondequoit Chapter DAR.)

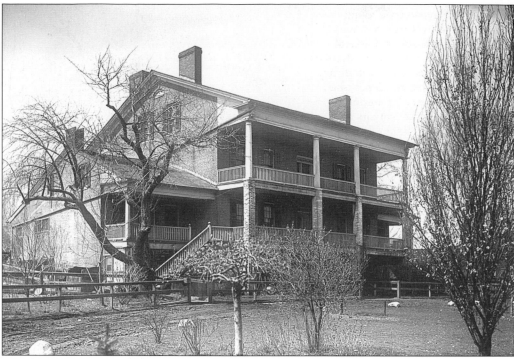

Another wonderful early structure that remains with us is the Spring House (on Monroe Avenue), an Erie Canal inn that still operates as a restaurant. The canal bed remains behind the structure, as does a nearby set of locks. Stagecoach travelers would sometimes transfer to a canal packet here for a smoother ride to Rochester. In this *c.* 1920s view, the Spring House still retains its original rural charm. This was a grand and sophisticated structure for its time, with details heralding the upcoming Greek Revival era. (Courtesy Irondequoit Chapter DAR.)

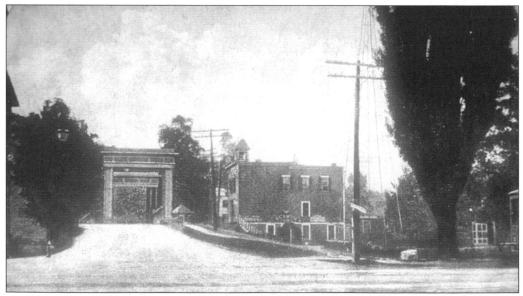

An early postcard view of Pittsford shows the Erie Canal bridge in the heart of town. Before the canal, East Avenue was often referred to as the Road to Pittsford.

The Greek Revival style found fertile ground in Rochester, as evidenced in the stately General Kling residence. It stood on Monroe Avenue, some distance west of the Spring House, and was demolished for a nursing home. Rochester's fame as a Greek Revival city probably had little to do with its being settled by three southern gentlemen (Nathaniel Rochester, William Fitzhugh, and Charles Carroll), but Rochester's examples of that style rivaled anything in the South. The classic upstate New York Greek Revival is admired around the country. (Courtesy Landmark Society of Western New York, Carl Hersey collection.)

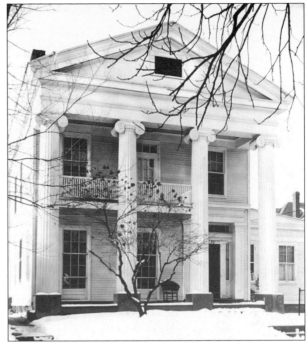

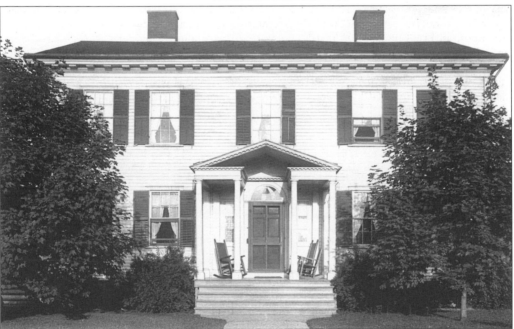

The Oliver Culver Tavern, at 70 East Boulevard, was moved here in 1906 from its original corner location on East Avenue. In the 1850s, it faced a tollgate for users of the Brighton Plank Road, which ran east to the hamlet of Brighton Corners. The building is a lovely Federal-styled residence-inn with beautiful interior detailing. The entire second floor is a ballroom with a sprung double-floor system designed to absorb the stress of sashaying guests. Elizabeth Holahan, a local preservationist, maintained the property as her home until her death in 2001. This view dates from the 1920s. (Courtesy Irondequoit Chapter DAR.)

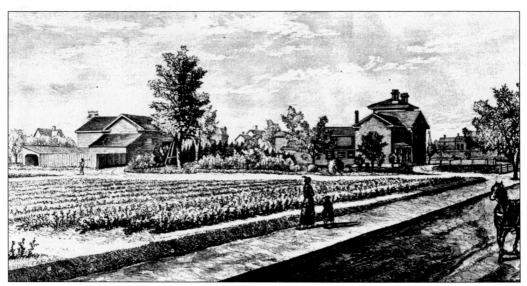

James Vick's home and expansive gardens are depicted in an 1877 engraving. Vick and other successful seedsmen had nurseries in the East Avenue area. He parceled his nursery and racecourse into Vick Park A and B. The nursery was a popular place to visit as a kind of public garden. The avenue is noted as much for its remarkable trees and gardens as for its architecture. Once a mansion was completed, the family would turn their thoughts to landscaping it. That required numerous visits to nearby nurseries.

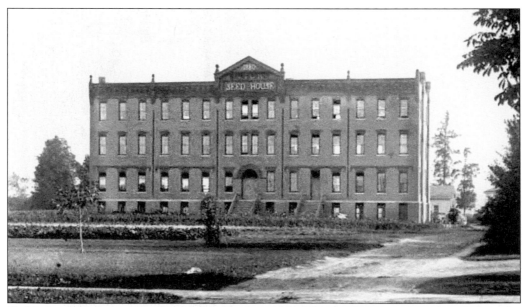

Vick's Seed House, on East Avenue, was built in 1880. The warehouse processed seeds from the 100-acre nursery stock for Vick's lucrative nationwide mail-order seed catalogs. Vick also had a 60-acre nursery near Lake Ontario. His sons took over the business when he died in 1882.

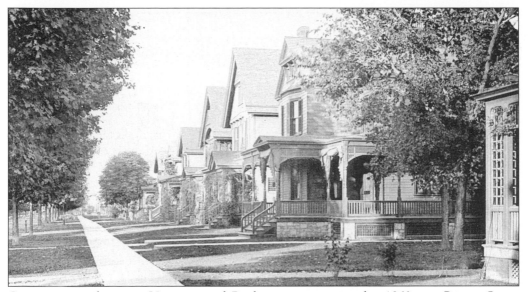

Construction of a new University of Rochester campus in the 1860s on Prince Street supplanted the city's intellectual center from the Third Ward to the east side. A new social colony sprung up, and older existing mansions soon had impressive new neighbors. Citizens eager to live near the mansions but without the wealth to build them gladly settled for the highly fashionable side streets. Vick Park A, pictured here in 1890, was developed in the 1870s by James Vick. (Courtesy Rochester Public Library Local History Division.)

James Vick was born in Portsmouth, England, in 1818. As a youngster, he played with Charles Dickens. The two remained lifelong friends. Vick came to America in 1833 and apprenticed as a printer in New York City. He came to Rochester c. 1837 to pursue an interest in horticulture that led to a successful flower cultivation and seed business. He helped earn Rochester the name Flower City. (Courtesy Rochester Public Library Local History Division.)

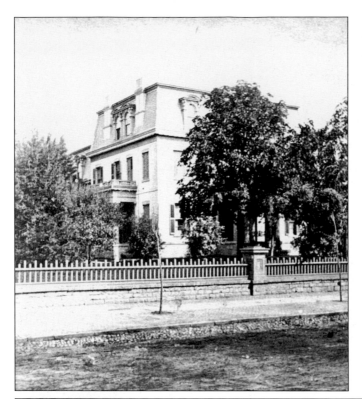

In the late 1830s, while Rochester was still the Flour City, pioneer merchant and druggist William Pitkin built the mansion captured here in an 1870 stereoview. It is one of three significant Greek Revivals still with us. They were built when the avenue was a rural dirt road. Subsequent owners included Daniel and Helen Powers and their five children. Daniel Powers built the city's most famous commercial structure of that time, the Powers Building.

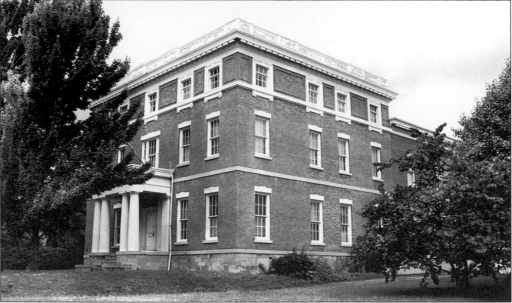

In the early 1900s, noted local architect J. Foster Warner renovated the house. A third floor and some impressive roof adornments were added. The home stood empty for many years. Repeated newspaper articles lamented its fate and featured disturbing photographs of its deterioration. It was slated for demolition several times and was finally saved when the local Boy Scouts of America acquired it for their headquarters. This contemporary view shows how well it is maintained.

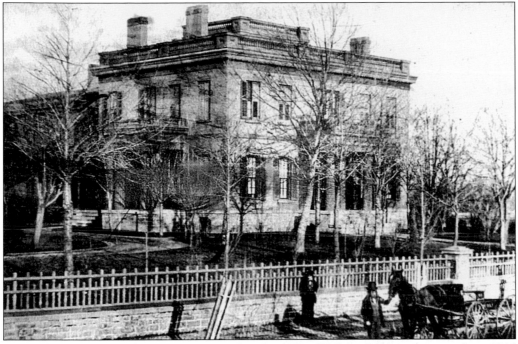

The Pitkin mansion is shown as it appeared in the 1850s. William Pitkin was mayor from 1845 to 1847. A widower, he married Louisa Rochester, the youngest daughter of Colonel Rochester, in 1849. Louisa did not care for the rural setting and persuaded her husband to move back to the Third Ward. In spite of the noble gentry around her, she may have held to the notion that only the lower class lived in the country. In 1851, William Pitkin sold the house to Azariah Boody, who lived there while serving as congressman from the Rochester District. In 1855, Boody sold the house to Daniel and Helen Powers, who added the third floor.

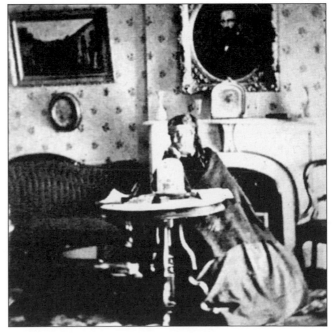

Mrs. James Upton Jr. leans into a thoughtful pose in this 1870 view of her Victorian parlor, probably located in one of the Upton homes on Upton Place.

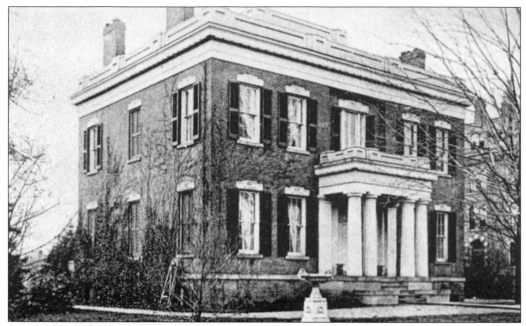

This impressive Greek Revival, part of a group of three that include the Pitkin house and Woodside, was built in 1842 by Aaron Erickson, a wool merchant and banker. Erickson had advanced money to three young men recently arrived in Rochester who would start the renowned dry goods company Sibley, Lindsay and Curr. The house was the work of local designer Nehemiah Osborn. It was later known as the Perkins house when daughter Caroline and husband Gillman Hill Perkins took it over. The house later became the Genesee Valley Club. Two wings were added under the plans of New York architect John du Fais. Today, the landscaped grounds, brick walks, and Colonial fence create a parklike setting on the avenue.

Caroline Erickson, depicted here in a Grove Gilbert portrait, was born in 1835 to parents Aaron and the former Hannah Beckoven of New York. The family moved into the above home in 1844. Two dining rooms and large parlors, both with folding doors, flank the main center hallway. The doors were opened during the grand-scale entertaining the home was famous for. Caroline received her early education at Miss Seward's Seminary, on Alexander Street, and was later sent to New York to finish her education. She married Third Warder Gillman Hill Perkins in 1857. They embarked on a two-month honeymoon that brought an admonishment from her father that they return to what "duty, propriety and common sense demanded." Caroline lived up to her father's expectations and devoted much of her time to philanthropic pursuits. (Courtesy Rochester Public Library.)

Caroline Erickson Perkins was, according to her friend Virginia Jeffrey Smith, "beautiful all her life." Caroline and her husband, Gill, had eight children, six of whom survived to adulthood. In her first year of marriage, she founded the Rochester Industrial School. Having a deaf daughter, Caroline helped found the Rochester School for the Deaf in 1876. In 1885, she and her family moved back into her childhood home, pictured on page 18. The Perkins continued philanthropic efforts to the end. Caroline died in Palm Beach in 1919. Virginia remembered her as "a lovely person—product of an era which has passed."

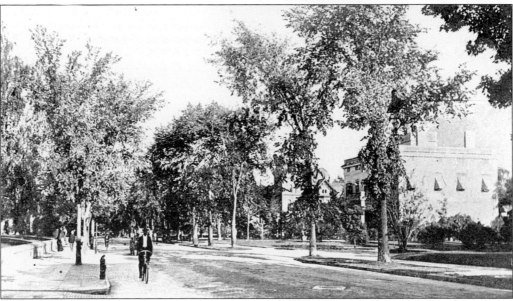

The elms along the avenue are not fully mature in this 1890 view. The house on the right is Woodside, on the corner of East Avenue and Sibley Place. Eventually, the crowns of the elms touched across the street to form a shady canopy. The concept of landscaping fashionable streets with trees did not catch on in America until the 1870s, but East Avenue got an earlier start when Josiah Bissell planted a mile-long row of horse chestnut trees from East Main to his nursery in the 1850s. Increased traffic would stress the trees. Horses hitched to posts along the road would chew the bark, which made the horses sick and killed the trees.

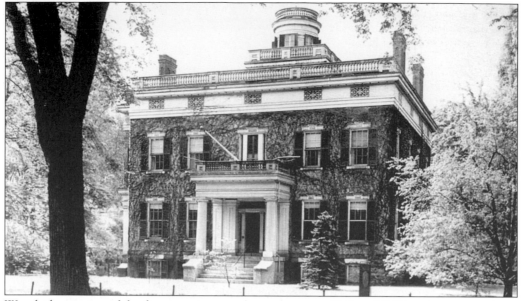

Woodside was one of the first mansions on the new avenue. Built *c.* 1840 by pioneer merchant Silas O. Smith, it remains one of most cherished structures in the district. Note the rich details that include a cupola, frieze band with iron grills, and balustrades. It is now the headquarters of the Rochester Historical Society and is the third of a group of early Greek Revivals that have survived. It was the residence of Mrs. R. Willard when this photograph was taken in the 1930s, during the Great Depression.

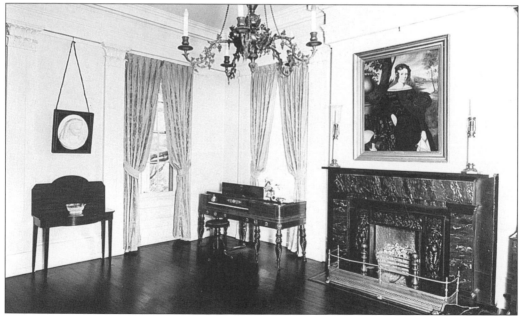

The classic elements of the Greek Revival interior are evident in a view of one of Woodside's parlors. A wooded area beside the house inspired the name Woodside. Only the sounds of hoofbeats trundling buggies or the steady gait of matched teams bringing stages from the Oliver Culver or Bloss taverns to Colonel Rochester's bustling mill town disturbed the otherwise peaceful setting of the estate. (Courtesy Landmark Society of Western New York.)

Woodside's cantilevered staircase rises in a decreasing spiral into the cupola. The former Seba Hand Ward, wife to Silas O. Smith, wanted to build a home near her Ward and Selden relatives in a large private grove east of the village, now Grove Street. The family compound could not accommodate the large home Silas wanted, so he built Woodside on the rustic country road recently named East Avenue. Many wives were reluctant to live in "the country." Most preferred the Third Ward, then the colorful hub of Rochester society. Some wives prevailed in getting their husbands to sell their East Avenue mansions and return to that west-side community. (Courtesy Landmark Society of Western New York.)

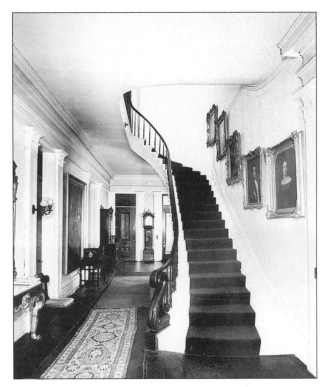

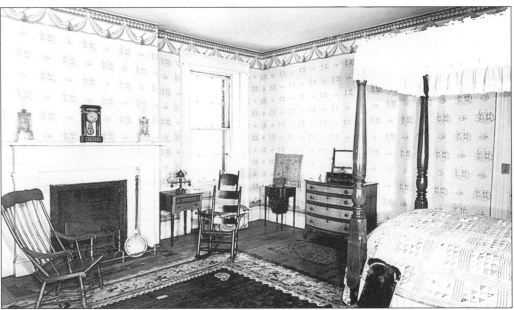

This spacious and comfortable Woodside bedroom would have required plenty of wood during the winter. There is a bed warmer propped against the fireplace. Even with a good fire going, to stray more than five feet away from a hearth was to enter chilliness. Water left in commodes would sometimes freeze overnight. Many early sofas, beds, and chairs had casters that allowed servants to wheel them by sun-filled windows during cold days. (Courtesy Landmark Society of Western New York.)

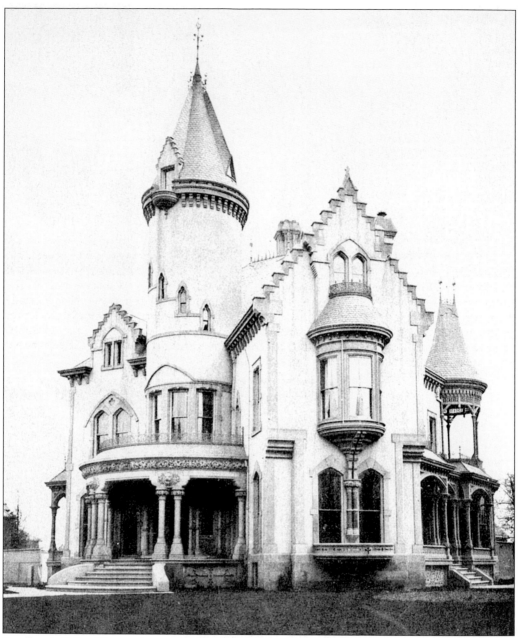

Patent-medicine king and promoter W.W. Warner amassed a fortune selling his Warner's Safe Liver Pills and Warner's Safe Kidney Cure worldwide. He ran his empire from his impressive Warner's Building, on St. Paul Street. The romantic turreted fantasy above was his residence on East Avenue. He sold his business in 1890. Three years later, the Panic of 1893 and some bad mine investments wiped out his fortune. His Rhineland-inspired mansion, which graced the corner of East Avenue and South Goodman, cost $150,000 and was considered Rochester's most beautiful home. It was used as a clubhouse but steadily decayed. Its full splendor would never return, and in 1929 it was demolished.

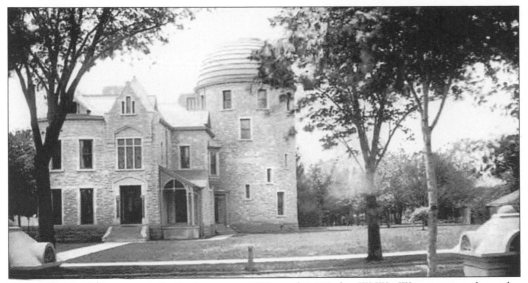

The Warner Observatory, built between 1878 and 1882 by W.W. Warner, stood at the southwest corner of East Avenue and Arnold Park. With true promotional zeal, Warner made it the only observatory in America open to the public. It was a requirement of social Rochester to be seen arriving in a smart carriage to observe the heavens through the 16-inch telescope. This stereoview shows the 31-foot-diameter tower topped with its dome and the substantial stone house built for resident astronomer Lewis Swift.

Amateur astronomer Lewis Swift ponders the 16-inch telescope inside the galvanized dome of the Warner Observatory. Swift, nicknamed "the Professor" because of all the comets and celestial objects he discovered, was sole operator of the observatory. He left Rochester in a huff when a structure was built nearby that cut off his otherwise unobstructed view of the night skies. He moved to California and laid the foundation for the future Mount Wilson and Palomar Observatories.

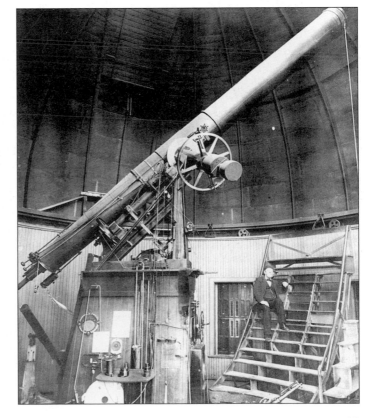

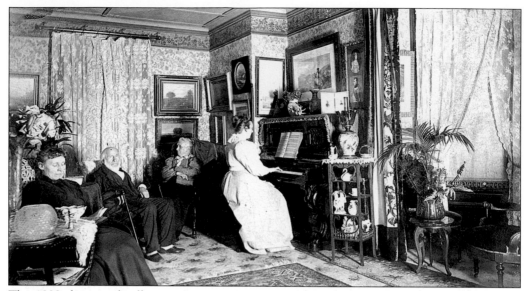

This 1888 photograph offers an interesting interior view of the McGonegal home, at 44 Vick Park A. George and Louise McGonegal are seated at the back; the woman seated on the left is unidentified. Daughter Bertha is playing the piano. Most young women learned the piano back then, as it was a regular form of entertainment before radio and television. Many homes had music rooms to accommodate small recitals. (Courtesy Rochester Public Library Local History Division.)

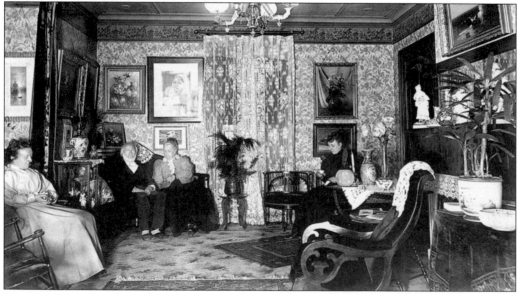

The McGonegals relax in the parlor of their Vick Park A home. George McGonegal was the Monroe County superintendent of the poor for 24 years. Even the more modest side streets boasted homes with twin parlors, salons, libraries, and smoking rooms. Although they usually did not have the great halls and ballrooms or loggias where wealthy patrons met to discuss civic undertakings, simple music rooms provided spaces for more intimate gatherings. (Courtesy Rochester Public Library Local History Division.)

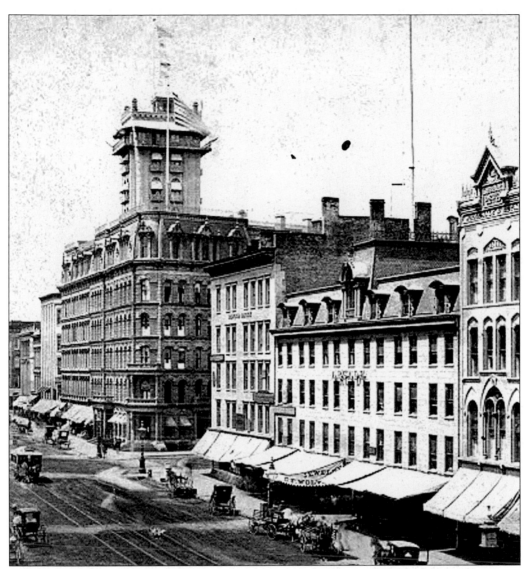

Post–Civil War Rochester finds a vibrant Four Corners. This 1880 stereoview shows the Powers Building with its tower before an additional story was added. The Reynolds Arcade is the long structure on the right. Its most important tenant was Western Union. Defections from the Third Ward to the new social colony at East Avenue continued. The ward succeeded in keeping the commercial end of the city on the west side, although the intellectual and social centers were moving east. The industrial and social themes of cities were dramatically changed between 1850 and 1920, an era sometimes referred to as the Gilded Age. Rochester was at the forefront of those changes. Most eastern cities were port based. People lived close to the coastal and river ports where most trade and industry occurred. Third Wardians built close to the river and canal, where most commercial activity occurred. Improved transportation allowed the upper crust to move out. Rochester's industrial captains christened East Avenue as its grand approach, and it evolved into one of the finest of any city in America.

Hiram Sibley, president of Western Union, was Rochester's most wealthy citizen when he and his wife, Elizabeth, moved the family into their new Italianate-styled house. It was built in 1868 across the street from the Erickson mansion. This photograph was taken shortly thereafter. Along with elaborate gardens, Sibley built a deer park and goat yard (actually several live goats, a goat cart, and a pair of iron deer) to entertain the younger members of his growing clan, which included the Atkinsons and Watsons. He built an enclosed bicycle rink near the carriage house when bicycling became the new craze. In 1873, he bought Woodside and presented it as a wedding present to his son Hiram W. Sibley. Later, Sibley presented Woodside to his son-in-law Hobart F. Atkinson. Another family dwelling was built behind Woodside on the newly opened Sibley Place. (Courtesy Landmark Society of Western New York.)

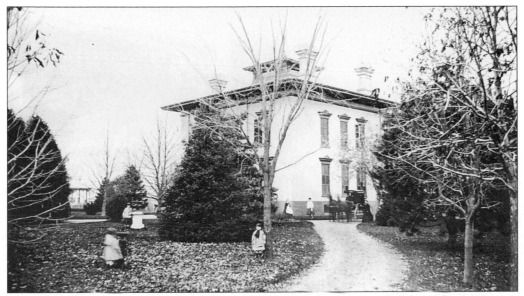

The Sibley home, pictured in 1868, was the scene of lavish entertaining. The Sibleys did much to beautify the avenue and heighten its prestige. Shortly after building his house, Hiram Sibley built one for his daughter Emily around the corner on Prince Street. When he persuaded his son Hiram W. Sibley to move his family from New York back to Rochester, he built them a large house beside this one, on the corner of East and Alexander, where the Treadway Inn was built in the 1950s. (Courtesy Landmark Society of Western New York.)

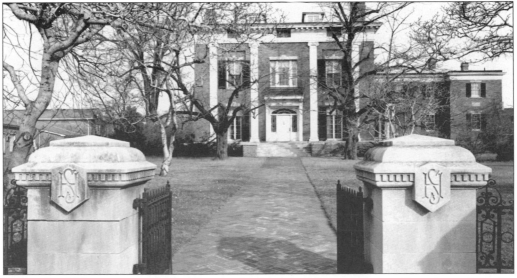

This is the Sibley mansion nearly 60 years after its remodeling in the neo-Georgian style in the early 20th century. It has not served as a residence since the 1970s. Several businesses have acquired it and have been sensitive to its architectural importance when adapting it to their uses. The home had a country manor setting and was not overly embellished as many were during the height of the Gilded Age. East Avenue residents spent wildly on their homes, both inside and out, during that span. The industrial captains—sometimes disparaged as robber barons—brought much of the great art to America and developed an unrivaled culture of craftsmanship here. (Photograph by Hans Padelt.)

Hiram Sibley, the patriarch of the Sibley clan and great benefactor, joined with William B. Morse and Ezra Cornell to acquire funds to build a telegraph line from Washington to Baltimore. This led to the formation of Western Union. In Sibley's 16 years as president, the property value of his telegraph offices increased from $220,000 to $48 million. He also invested in railroads, salt, and lumber. His enduring claim to gratitude resides not only in his industry but also in his endowment of institutions. Among them was Sibley Hall Library for the new University of Rochester and Sibley College of Mechanics' Arts at Cornell University.

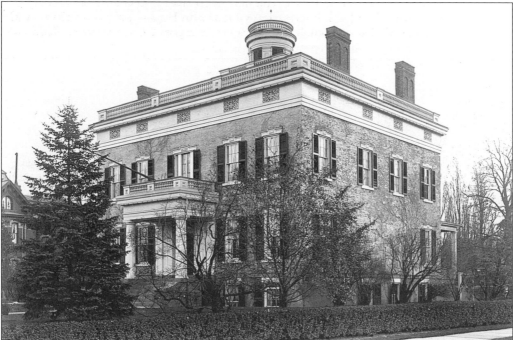

Woodside was included in the "Sibley compound" on East Avenue in 1873, when Hiram Sibley purchased it for a wedding present for his son Hiram W. Sibley. The newlyweds did not stay here long, as Margaret (Harper) Sibley desired to live in her native New York City. The mansion was used for two of the avenue's grandest weddings. (Courtesy Irondequoit Chapter DAR.)

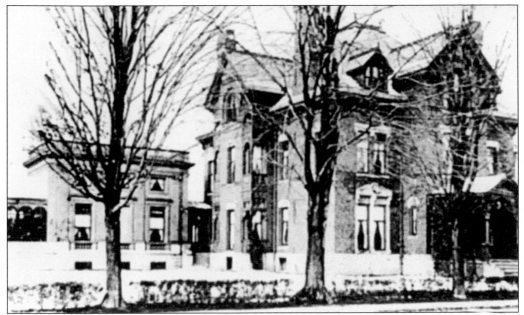

Hiram Sibley built this house at 11 Prince Street for his daughter Emily and her first husband, Isaac Averell. In 1891, Emily married James Sibley Watson. Behind the Prince Street homes was a large stable where son James Sibley Watson Jr. and his wife, Hildegarde, produced two silent movies in the late 1920s—*The Fall of the House of Usher* and *Lot in Sodom*. Both featured beautiful Hildegarde in the woman's lead. The movies received acclaim. Before Hollywood, America's movie center was Ithaca. It seems natural that with Hiram Sibley's partnership with Ezra Cornell, founder of Ithaca's Cornell University, and our own George Eastman, Rochester would not be long in exploring the new art of moviemaking.

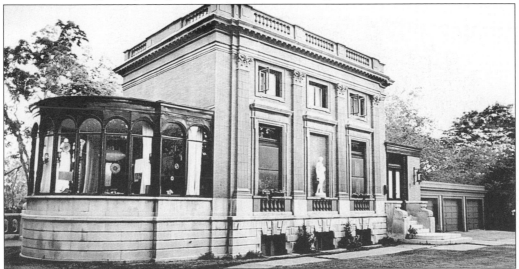

The Watson house was demolished in 1954, but the unique library wing was spared. The wing had been added to the main structure in 1903. It was designed by New York architect John du Fais. The unique structure was inspired by Versailles and is affectionately referred to as "the Petit Trianon." It is a beautifully maintained residence today. (Courtesy Landmark Society of Western New York.)

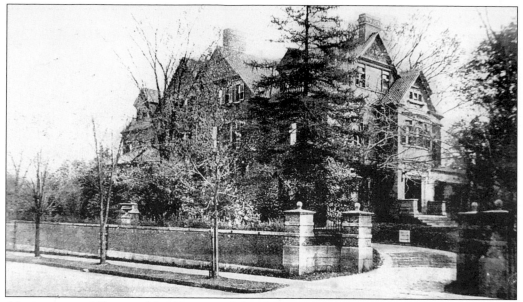

Having successfully persuaded his son and daughter-in-law to leave New York City and return to Rochester, Hiram Sibley built them this substantial stone mansion on the grounds of his estate. It occupied the corner of East and Alexander until the 1950s, when a Sibley family member sold it to Treadway Inn. The home was demolished to make way for the new inn, but much of the stone fence was saved. (Courtesy Landmark Society of Western New York.)

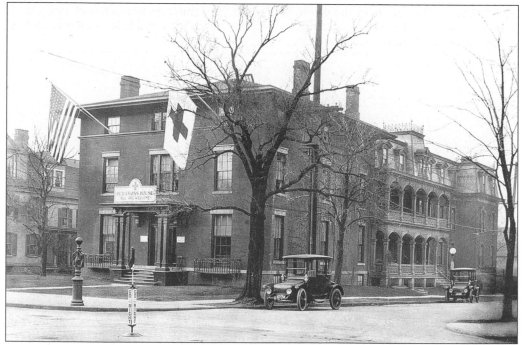

The Red Cross headquarters, on the corner of East and Alexander, was the site of much World War I relief work. The Rochester Friendly House occupied the building for a while. It stood across the street from the Sibley home seen in the above photograph. In the 1920s, this structure was replaced with the Fitch building. (Courtesy Rochester Public Library Local History Division.)

The Hiram Sibley building, at 311 Alexander Street, is one of Rochester's most beautiful. It is the more elegant of the two built across from each other at East and Alexander, a formal gateway between the commercial and residential districts. The Sibleys, in the tradition of grand avenue patrons across America, felt it was their duty to beautify their city in addition to establishing universities, galleries, hospitals, and theaters. Sibley used the Boston architectural firm Bulfinch and Abbot to create this masterpiece. Other grand avenues allowed commercial encroachment into the residential district. The Sibley and Fitch buildings were intended as firm break-off points to prevent that here.

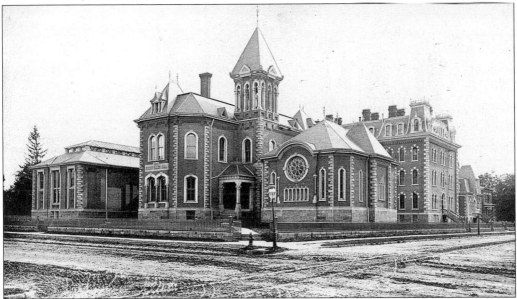

The Rochester Theological Seminary completes the fourth corner of the historic East and Alexander intersection. At the forefront is Rockefeller Hall, built by the great benefactor John D. Rockefeller. It contained a chapel, lecture room, and museum. Just behind is Trevor Hall, also part of the seminary campus. Rockefeller Hall came down in 1929.

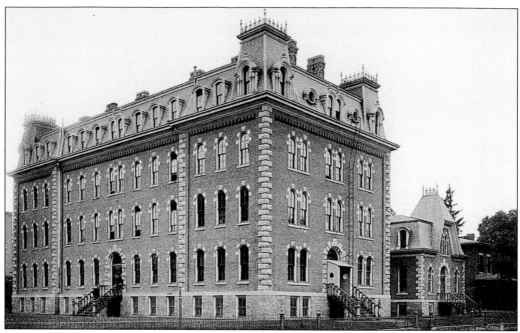

Trevor Hall would have additional wings added as the Rochester Theological Seminary expanded its campus. Defections from the Third Ward increased, as it was obvious that the intellectual and social center of the city was being transplanted to the new social colony on the east side of the river. (Courtesy Rochester Public Library Local History Division.)

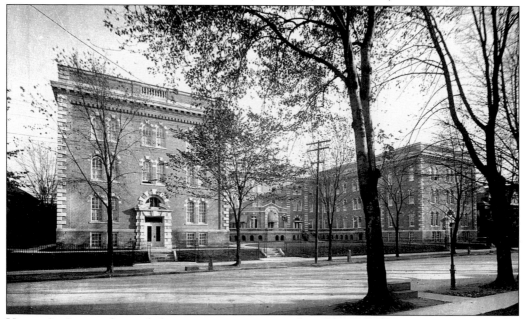

Henry A. Strong donated the money to construct the additional portions of the Rochester Theological Seminary. In honor of his late father, it was called Alvah Strong Hall. It was designed by J. Foster Warner and was completed in 1907. The seminary evolved into Rochester Colgate Divinity. Alvah Strong Hall is all that remains of the original seminary. It became apartments in 1943. (Courtesy Rochester Public Library Local History Division.)

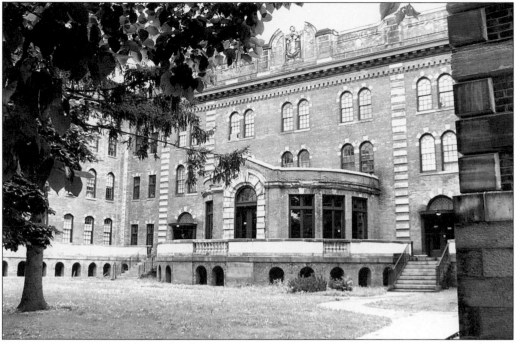

A contemporary view shows the former seminary as the Alexandrian Apartments. Like the Hiram Sibley building across the street, it too was inspired by strong European traditions.

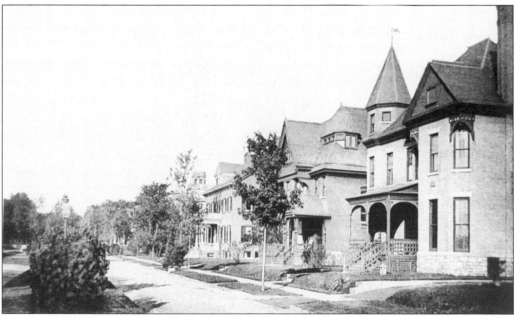

An economic depression in the mid-1870s slowed the construction of mansions on East Avenue. By 1880, the movement to make the avenue the city's most beautiful street resumed. Side streets with grass malls and parklike settings were developed, such as Sibley Place, which was built along the Woodside estate. By the mid-1880s, there were five such parks: Arnold, Sibley, Upton, Portsmouth, and Granger.

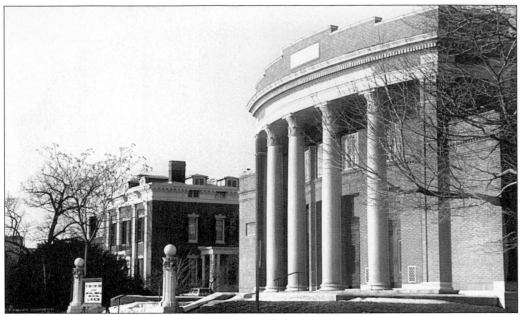

The Church of Christ, Scientist opened on the corner of East and Prince in 1916. The Italian Renaissance structure cost an estimated $250,000. To its left is the Sibley mansion. Many grand avenues became the preferred address of religious edifices, museums, and high-end businesses, as well many noted citizens. This photograph dates from the 1980s.

A closer look at the Hiram Sibley building, on the corner of East and Alexander, reveals its rich details. To the right of it is the Fitch building, across East Avenue. Together they formed a formal entrance. Romantic thinking in the conception of grand avenues around the world included monumental arches or gateways at an entrance, such as Arc de Triomphe, the Brandenburg Gates, or St. Petersburg's arched entrance of Nevsky Prospekt. East Avenue's entrance was less grandiose but was certainly impressive.

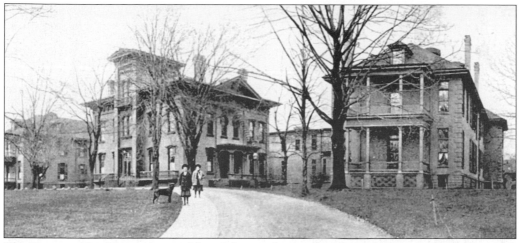

The Homeopathic Hospital moved from Monroe Avenue to Alexander Street in 1894. In 1926, it became Genesee Hospital. The large structure in the center was the former house of the Freeman Clarke family, who donated it to the hospital for use as an administrative building. The Watson Pavilion (left) was the gift of Mrs. D.A. Watson. The Sibley Pavilion (right) was a gift from Elizabeth Sibley, the widow of Hiram Sibley. (Courtesy Rochester Public Library Local History Division.)

Freeman Clarke, who donated his massive Alexander Street home to the Homeopathic Hospital, had many successes. Among them was his position as treasurer and first director of the Rochester, Lockport and Niagara Railroad (later assimilated into the New York Central). He was elected representative to the 38th, 42nd, and 43rd congresses. During the Civil War, Lincoln appointed him comptroller of the currency, and he helped enact some of the most important financial legislation of the war, including the organization of the national banks. He married Henrietta J. Ward, the youngest daughter of Dr. Levi Ward, in 1833. He died in 1887.

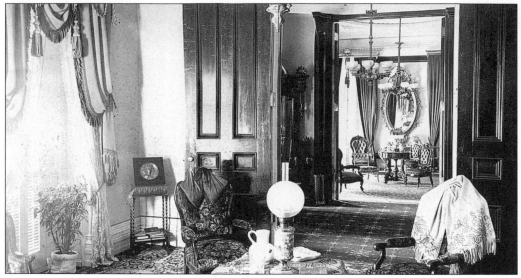

A rare view of one of the large parlors of Freeman and Henrietta Clarke's mansion shows the scale of opulence of the Gilded Age. Adorned in high Victorian elegance, it features deep moldings, high ceilings, chandeliers, and elaborate window treatments. The Clarkes were known for sumptuous entertaining, and guests were anxious to linger within such grandeur. Like the houses in the Third Ward, these homes were built with entertaining in mind. Most had music rooms or ballrooms with orchestra galleries and many bedrooms for visiting guests. It would be the height of rudeness to put up a visitor at a hotel. (Courtesy Rochester Public Library Local History Division.)

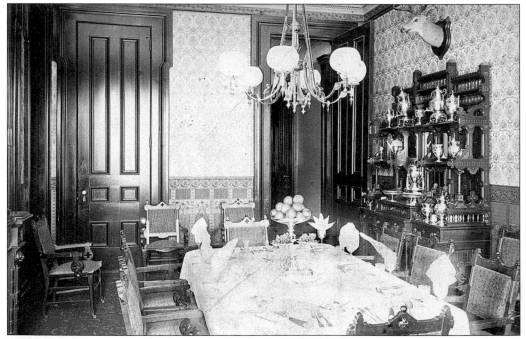

The Clarke dining room shows off the family's fine china, silver, and crystal. A house of this size required live-in housemaids, nannies, valets, chambermaids, and butlers. (Courtesy Rochester Public Library Local History Division.)

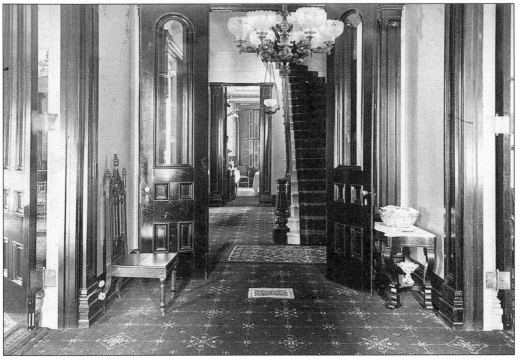

The massiveness of the Clarke house is obvious in this image of the entry hall. Note the many tall folding doors. In the days before efficient heating systems, many doors were needed to keep drafts down. (Courtesy Rochester Public Library Local History Division.)

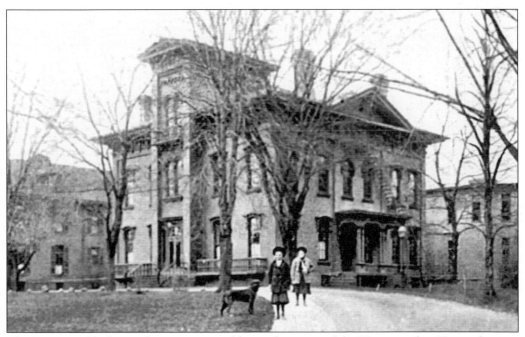

The Freeman Clarke residence is pictured here when part of the Homeopathic Hospital.

An impressive home on Oxford Street turns its porch steps invitingly toward the sidewalk at a time when evening promenades usually meant a stop to visit neighbors. This view dates from the 1890s. Certainly this home required many servants to maintain it. They usually occupied the hotter upper rooms. Note the awnings. When windows were opened a bit on hot days, a draft would develop in the shadows along the sill that helped draw the heat from the home.

An annual rite of spring remains enjoying the blossoming of magnolias planted down Oxford Street's center park. Note that the street is paved with bricks. Oxford's promoters were among the first to petition the city in the 1870s to spray the roadway often to keep down dust. Before brick or asphalt paving, streets were graded, crowned, and then surfaced with a layer of crushed stone.

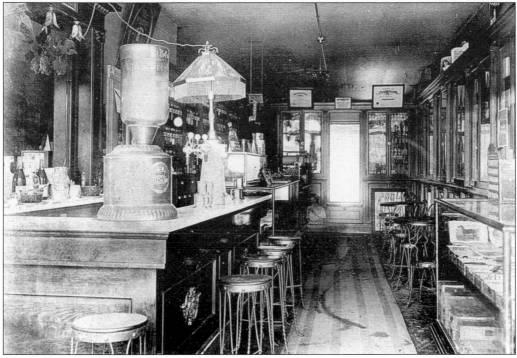

A postcard view of Oxford Pharmacy c. 1910 shows a world of delights packed into a small place. There is a counter for sandwiches with a prominent soda fountain. On the right is a well-stocked cigar case. Nannies and butlers from the avenue would bring children here for candy or an ice cream. Oxford Street was laid out in the 1870s in an area formerly known as Hooker's Farms. The street remains fairly intact. (Courtesy Rochester Public Library Local History Division.)

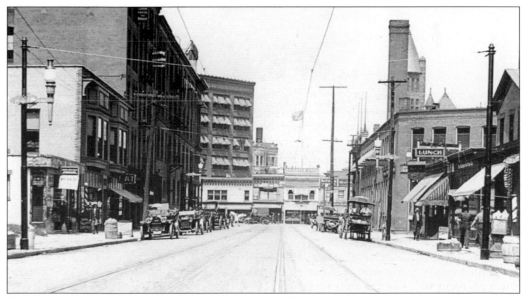

This early view of Elm Street looks toward where the Liberty Pole now stands on East Main. Midtown would be built on the left.

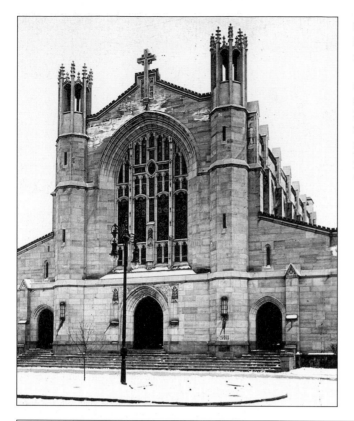

Church of the Blessed Sacrament was built in 1912, replacing the congregation's 1902 edifice. Architects Gordon and Madden had it built in gray sandstone. Located on Oxford Street, it remains a central feature of the Park-Meigs neighborhood. (Courtesy Rochester Public Library Local History Division.)

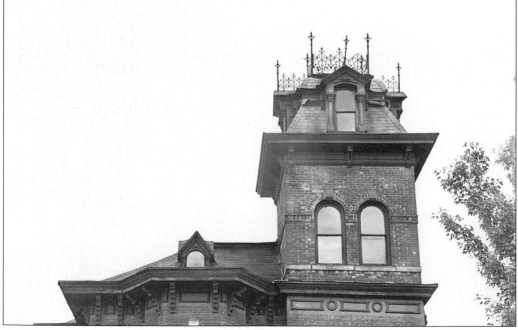

Rooflines crested with iron ornamentation drew the eye upward and sometimes added a delicate finish to otherwise severe-looking structures such as this former residence on Alexander Street.

This portrait of students beside the original school No. 23, on Park Avenue, was taken in the early 1890s. Josiah Bissell, an early East Avenue resident, recalled the school days of the 1840s and 1850s in his address to the Rochester Historical Society in 1891. He stated, "The evolution of the last fifty years is shown nowhere more than in the education of boys. At that time the schoolboy had no rights. . . . Treatment most cruel, too sickening to be described here was common, and the worst of it was that parents felt bound to submit to it. Many of our citizens lament injuries which have impaired their usefulness for life, received at school under the barbarous tyranny of teachers, whose names are well known." (Courtesy Rochester Public Library.)

A school bus filled with first- and second-graders from Allen's Creek School, on East Avenue, shows students rather joyous considering it is the first day of school. This image dates from 1987. (Courtesy Brighton Municipal Historian Collection.)

The Noyes residence stood at the corner of Alexander Street and Gardiner Park. It was razed in 1929 to make way for the medical arts building. (Courtesy Rochester Public Library.)

Located on the southwest corner of Brunswick and Park, this c. 1894 building has housed several important institutions. It was Bradstreet School for years and was later operated by Dr. John Whitbeck as a private hospital. From 1907 to 1975, it was Park Avenue Hospital, which moved to Greece then and was reorganized as Park Ridge Hospital. (Courtesy Rochester Public Library Local History Division.)

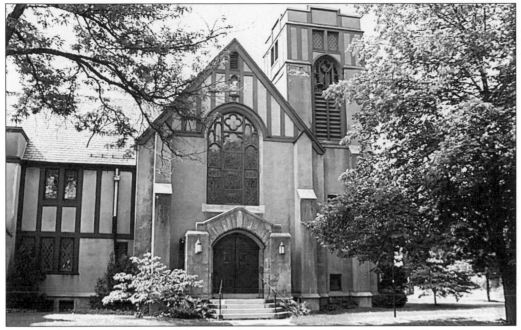

Immanuel Baptist Church was built on Park Avenue in 1926. Designed by J. Foster Warner in the English Gothic style, it has elements found in St. Margaret's Church in London. In the summer, vines propagated from clippings taken in England cover the outside walls. George Eastman's organist, Elizabeth Harper Vaughn, played the 1926 Moller pipe organ for many years. She sometimes talked about that March morning in 1932 when she arrived at Eastman's house for his morning recital only to be turned away by house servants. Eastman had taken his life the night before. This church is on the National Register of Historic Places.

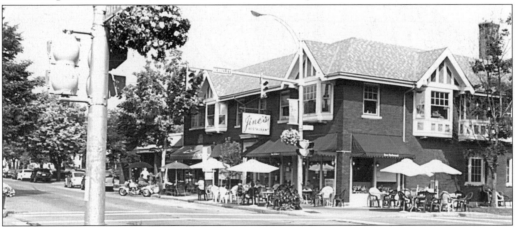

This view of the corner of Park and Berkley shows the successes of the Park Avenue Merchants Association and East Avenue Preservation District. This "Greenwich Village" of Rochester has (in addition to many historic Queen Annes, Tudors, and Victorians) more than 80 shops, restaurants, and small businesses. The district was built along old flower nurseries, and the promoters wanted to dignify some of the streets with collegiate street names like Dartmouth, Rutgers, Oxford, Vassar, Berkeley, Cornell, and Cambridge. Others were chosen to inspire a British association, such as Barrington, Buckingham, and Westminster. The area was serviced first by horsecars and later by electric trolleys.

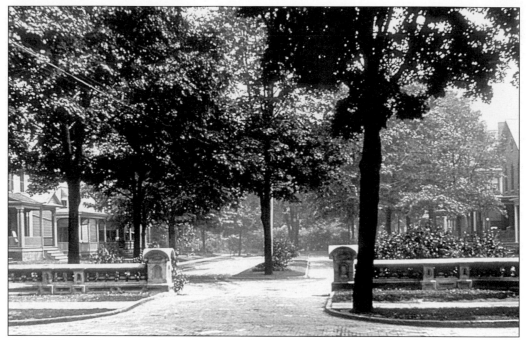

Slowly filling with morning light, Arnold Park shimmers with restful allure. The lushness of the street is apparent. Although these parklike settings offered a kind of retreat for affluent Rochesterians, young men, exercising their horses, could not resist racing them not just around the center malls but also up and down the avenue. The dust raised by this brought protests, and restrictions were laid down. This *c.* 1900 view looks toward Park Avenue from East Avenue.

Henry Ward was professor of natural history at the University of Rochester when it relocated from West Main Street to the new campus west of the Genesee in the 1860s. Ward was born in 1834 and died in 1906. He is remembered for many accomplishments, including founding Ward's Natural History Museum. (Courtesy Rochester Public Library Local History Division.)

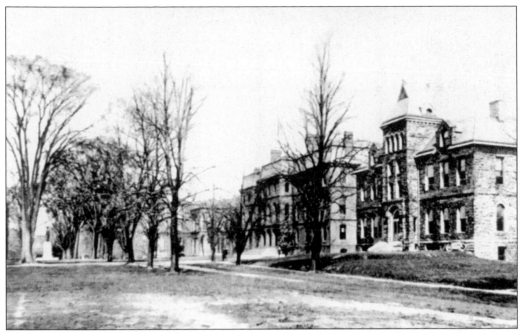

The Civil War put a cloud over the 1861 opening of the new University of Rochester. The campus was developed on the back acres of Azariah Boody's estate, the man who coaxed the university to the east side with the promise of donated acres. The main building (center) in this postcard image of the campus shows Anderson Hall, named after university president Martin B. Anderson.

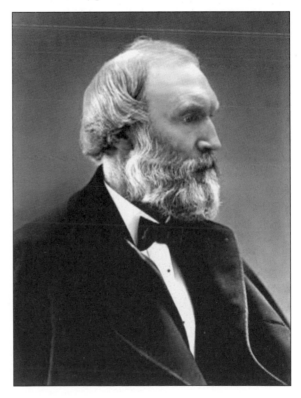

The Reverend Martin B. Anderson was president of the University of Rochester from 1853 until 1888. He was born in 1815 and died in 1890. The university was founded by the Baptists in 1850.

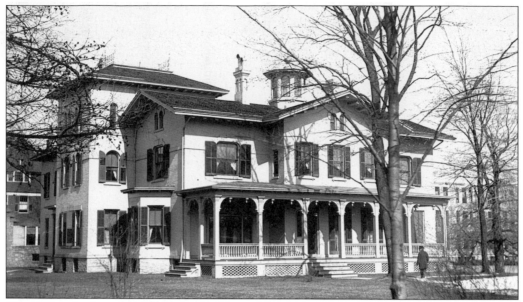

This home, built *c.* 1852 by John J. Van Zandt, was used as the residence of University of Rochester presidents from 1869 to 1932. George Eastman's mansion became the official home of the presidents after the death of the Kodak King. This Italianate-styled house stood on the corner of University Avenue and Prince Street. After 1932, it was named Harriet Seelye House and was used as a women's dormitory. It was demolished in 1956. (Courtesy Rochester Public Library Local History Division.)

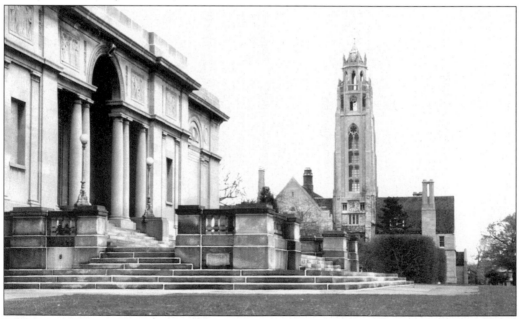

The Memorial Art Gallery (left) and Cutler Union were part of the old University of Rochester campus. Cutler Union, named after James Cutler, opened in 1933 as a women's building. Cutler was a Rochester mayor and talented architect of some of the avenue's most substantial dwellings. When this photograph was taken in the early 1980s, Cutler Union was part of the Memorial Art Gallery complex.

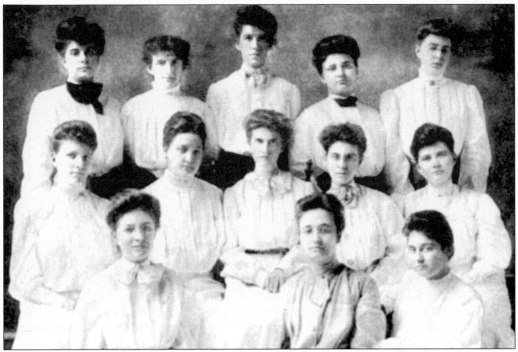

Women graduates from the University of Rochester pose for this 1906 class portrait. It is interesting to note that in 1890 the price for tuition was $20 a term. The entire year's expenses rarely exceeded $75. (Courtesy Rochester Public Library Local History Division.)

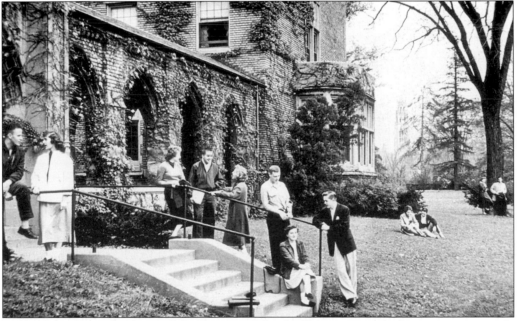

Students linger on the lawn of the Eastman School of Music women's dormitory in an early 1950s view. The dorm, built in the 1920s, later became part of the Rochester School of the Arts. The building stands on the north side of University Avenue between Alexander and Prince Streets. (Courtesy Rochester City Hall Photo Lab.)

Part of the original University of Rochester campus, this building, pictured in the early 1980s, later became the Rochester School of the Arts.

A contemporary view shows the building at the top of this page after remodeling.

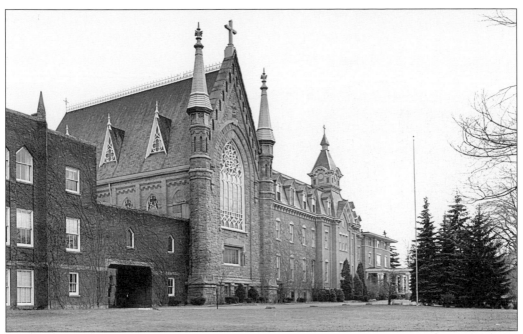

Much of the east side of Prince Street, a historic street that runs between East and University Avenues, is filled with the former Female Academy of the Sacred Heart, a grouping of five individually styled but adjoining structures. At the far end of this 1967 photograph is the 1845 residence where the academy started in 1863. The other structures were added in the 1880s and 1890s. The group has been recently converted to the Chapel Hill Apartments. (Photograph by Hans Padelt.)

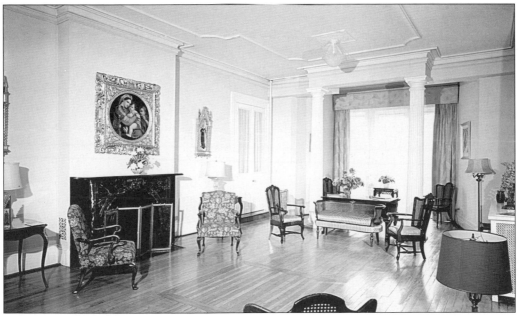

The rich interior of the original home where Sacred Heart Academy began in 1863 is shown here in a 1967 photograph. The school developed into an exclusive and expensive institution. (Photograph by Hans Padelt.)

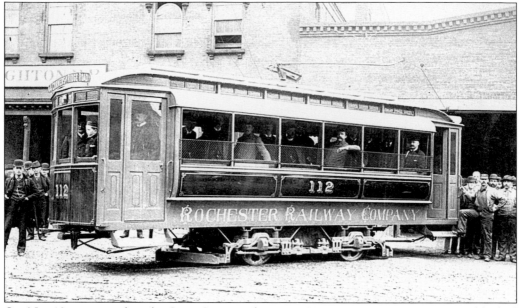

Car No. 12 is pictured at the State Street carbarn in 1890. In 1863, property owners blocked extension of the new horsecar tracks of the Rochester and Brighton Street Railway down East Avenue. Residents were content with service provided by the Omnibus Company, which (although antiquated) provided service for years. Horsecar service was provided to lower East Avenue residents by tracks along Main, Alexander, Clinton, and Monroe. (Courtesy Rochester Public Library Local History Division.)

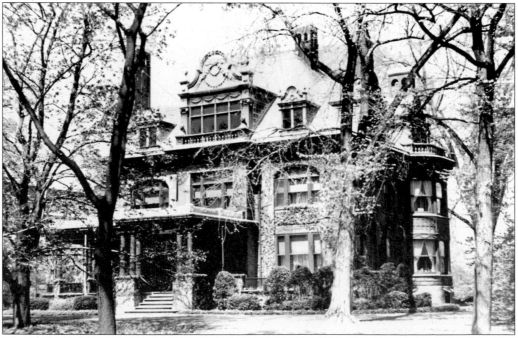

The Cunningham residence was one of the more impressive East Avenue mansions. Its elaborate gables, chimneys, and bays were exquisite. (Courtesy Landmark Society of Western New York.)

Two

THE BUSINESS DISTRICT

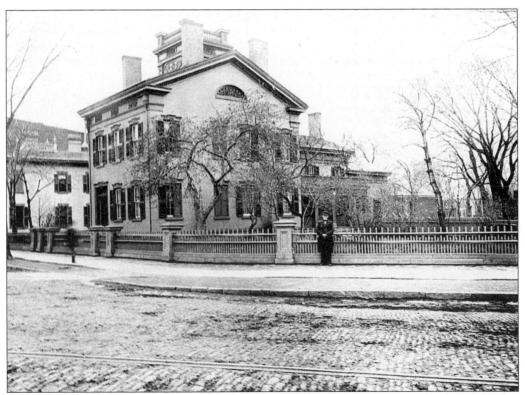

Originally, homes occupied the block between East Main and Alexander Streets. Pictured is the Nehemiah Osburn house, at the intersection of East Main, East Avenue, and Elm Street. Osburn, a wealthy contractor and architect, operated the noted Osburn House. His residence was later first headquarters for Security Trust. The homes here were quickly squeezed out by commercial expansion, as business owners were anxious to cater to the avenue's emerging elite.

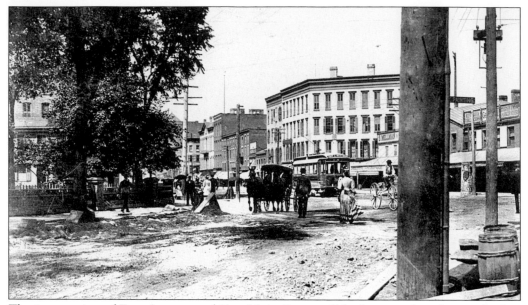

The intersection of East Avenue and East Main Street still had a rugged quality in the late 1880s. The building in the center would be the future site of Sibley, Lindsay and Curr—better known as Sibleys. To the right of that is where the Liberty Pole now stands. On the left, in shade, is fencing around Osburn's handsome Greek Revival. During the Civil War, his yard was the scene of rallies and fireworks displays. Main Street is paved with brick, while East Avenue remains macadamized. Hiram Sibley had overseen the application of a double layer of stone down the residential section of the avenue.

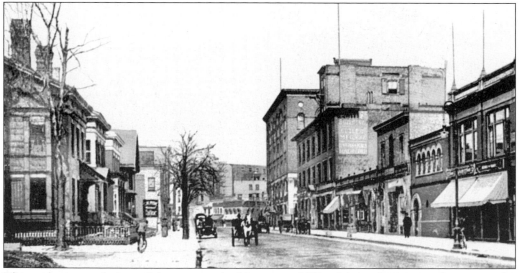

This early postcard view of the avenue, looking toward West Main, shows some homes on the left side. In 1891, a resident gave an address to the Rochester Historical Society wherein he described growing up here some 50 years earlier: "As I remember the sanitary arrangements of the neighborhood, I am surprised at the physical vigor and health of its residents. Every house had its cesspool, which seemed to collect and retain, rather than remove, the refuse matter committed to it. The wells yielded water heavy with lime [and] the imperfect sewage would not now be endured."

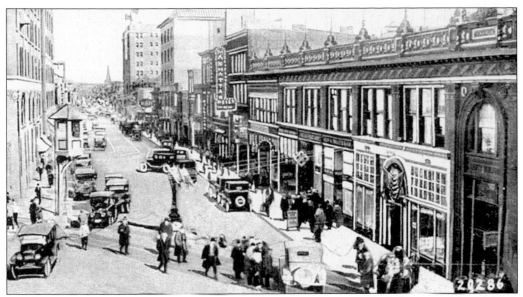

Another postcard captures the vigor of the avenue in the 1920s. The Liberty Building (right) is where the Osburn residence stood. It included in its tenants Laube's Old Spain restaurant. Slightly up the avenue was the Manhattan Restaurant, another favorite of residents, especially after a day of shopping at Sibleys or at Projansky's "custom furrier and tailor to gentlemen." Still farther along the block is the Regent Theater. The business section featured only the finest jewelers, fur stores, haberdashers, clothiers, and carpet stores. The carriage trade has rejected horses in favor of automobiles.

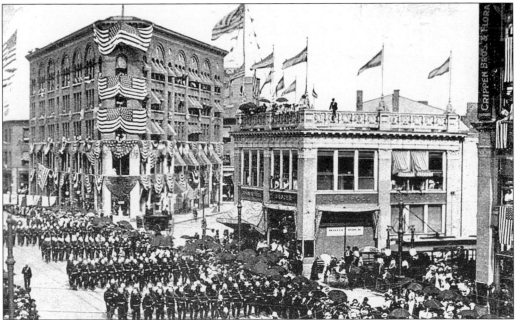

Canadian troops march past the East Main and East Avenue intersection during the 1899 Fourth of July parade. The Liberty Building is in the center. Note the trolley on Elm Street. The Canadians were invited in a celebration of international support. (Courtesy Rochester Public Library Local History Division.)

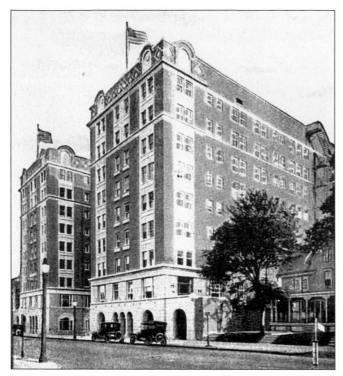

The grande dame of the commercial end was the Sagamore, a richly appointed high-end hotel. Chicago architects Gordon and Kaelber drew inspiration from Chicago's Surf Hotel during the designing stages. This 1920s view shows a residence butting up to its north side. In 1944, the Sagamore was taken over by Sheraton. In 1970, it was reworked to accommodate apartments, offices, and shops and was renamed 111 East Avenue. It later became East Avenue Commons.

This winter scene on the avenue dates from the 1890s. The view is from Chestnut, looking east toward Alexander. On the left is the Genesee Valley Club. The University Club stood at East and Broadway, and with typical snobbishness, membership was limited to men who attended only colleges of recognized standing. This block was semiresidential then. As commercialization overwhelmed the block, some houses would have storefronts added.

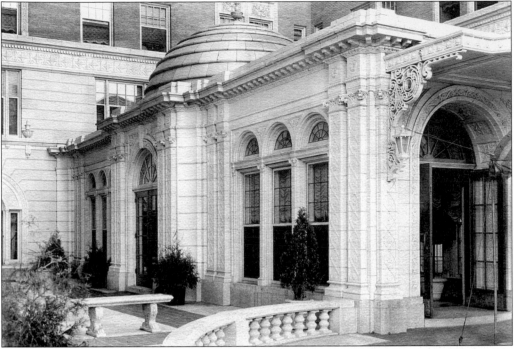

The exquisite entrance to the Sagamore represented a high point in architectural achievement. Guests arrived in limousines, Packard touring cars, and Rochester-made Cunninghams. (Walter D. Towne photograph, courtesy Rochester Public Library Local History Division.)

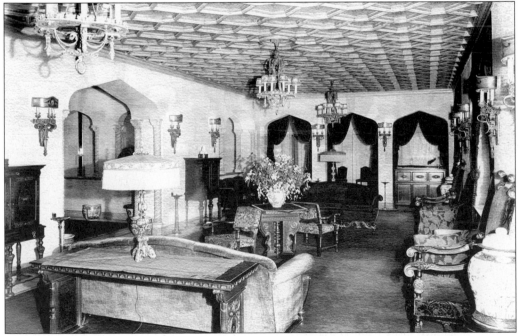

A sitting room off the lobby of the Sagamore Hotel was decorated in a kind of Arabian fantasy. This photograph, taken by Walter D. Towne, is part of an early promotional series. (Courtesy Rochester Public Library Local History Division.)

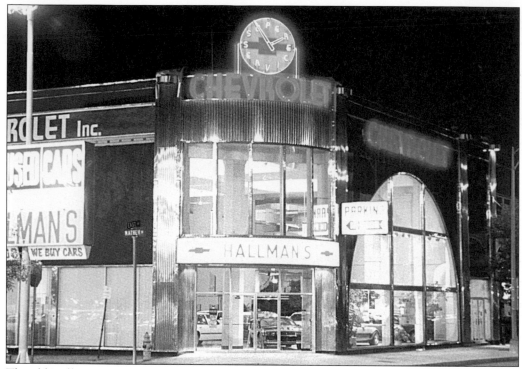

The old Hallmans Chevrolet dealership, on East Avenue, has always been an attraction because of its bold design, especially at night when it glows with an incandescence that harkens from the high-style days of the Art Deco era. The black glaze exterior, chrome trimmings, and massive arched window are glamorous especially under the vivid glow of red neon. This image is from the early 1980s.

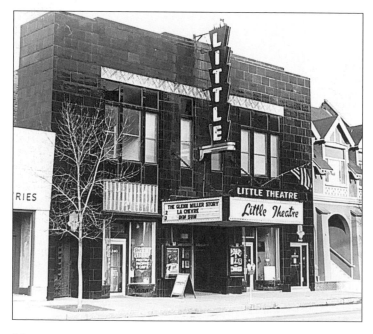

The Little Theater opened in 1929 on East Avenue. It is pictured here in the early 1980s after restoration. Like Hallmans, it is noted for its Art Deco styling. The theater offers multiple screens now, showing independent and foreign films. It also has a small restaurant and gallery, and features jazz on some nights.

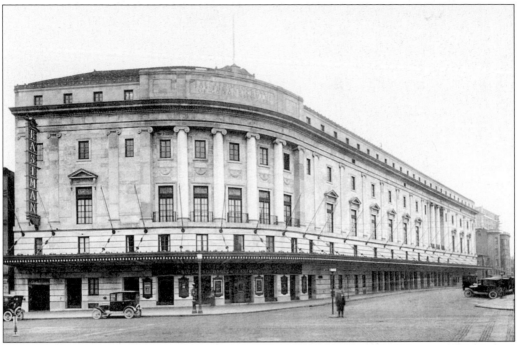

George Eastman funded most of the Eastman Theater, Eastman School of Music, and Rochester Philharmonic Orchestra as parts of the University of Rochester. These institutions made Rochester internationally known as a center for music studies. Gordon and Kaelber and McKim, Meade and White designed the theater. The latter firm was responsible for New York City's magnificent Pennsylvania Station. The Eastman Theater was another artistic victory for them. It was considered one of the most beautiful in America when it opened in 1922.

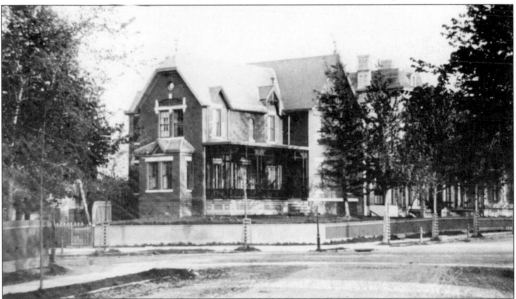

This is what the corner of East Main and Gibbs Street looked like before the Eastman Theater. Pictured is the Theodore Bacon family home. Residences extended from here down to East Avenue. (Courtesy Rochester Public Library Local History Division.)

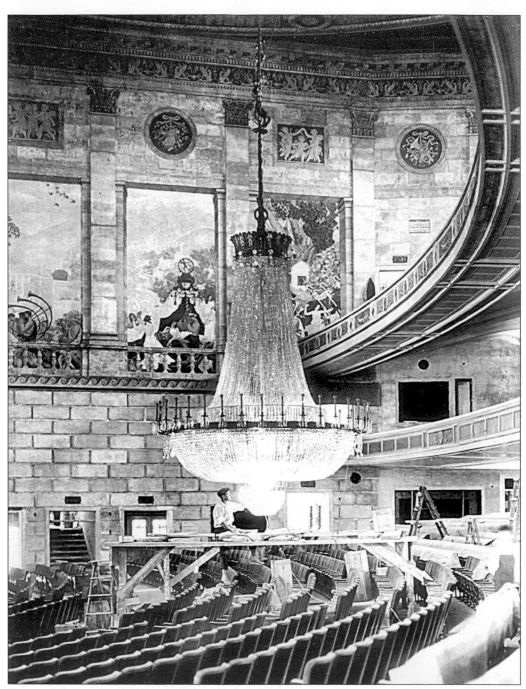

Some of the nation's top artisans worked on the Eastman Theater, including muralists Ezra Winter and Maxfield Parrish. The magnificent chandelier has been lowered for cleaning and bulb replacement. George Eastman had a huge 10,000-pipe organ installed in the concert hall, and it provided dramatic background music for the silent movies shown here. The main floor included Kilbourn Hall, a beautiful Italian Renaissance concert hall that the Kodak King dedicated in honor of his mother. The theater and schools contained additional studios, an assembly hall, practice rooms, and offices. (Courtesy Rochester City Hall Photo Lab.)

Future musicians, after hours of practice, put on a recital. This image dates from c. the 1950s. (Courtesy Rochester City Hall Photo Lab.)

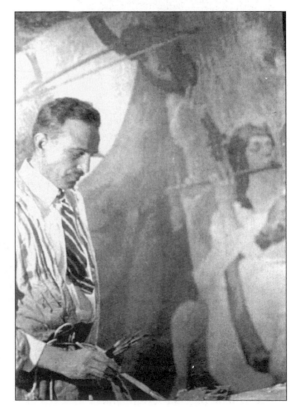

Distinguished muralist Ezra Winter poses beside one of his works during the completion phases of the Eastman Theater. He was the primary artist in a group of muralists commissioned to decorate the halls. (Courtesy Watanabe Special Collections, Sibley Music Library, Eastman School of Music.)

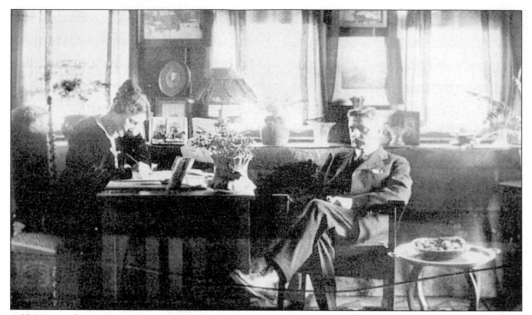

Alf Kingenberg, first director of the Eastman School of Music, sits in his office with his secretary. It was a dream of Alf and his wife, Alexandra, to establish an important music institute in Rochester. Through perseverance, they convinced University of Rochester president Rush Rhees and Kodak founder George Eastman to pursue this goal. The result was the Eastman School of Music, widely recognized as being "surpassed by no other in the world." (Courtesy Watanabe Special Collections, Sibley Music Library, Eastman School of Music.)

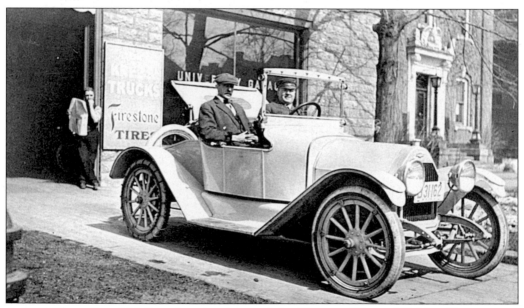

A 1915 Chevy Royal Mail roadster heads out of the Firestone Tire and Rubber Company on East Avenue. Firestone had been a fixture on lower East Avenue until the late 1980s. To the right is the entrance to the No. 3 Police Precinct Station. (Courtesy Rochester Public Library Local History Division.)

Charlotte Whitney Allen's 1936 Ford Cunningham is parked beside the Eastman Theater's marquee in this 1950s image taken by local photographer Jim Laragy. Allen was one of the more interesting personalities of the avenue. She spent much of her time in philanthropic endeavors. Her famous 4:00 "chilled glass hour" at her Oliver Street home was part of the lore of East Avenue. It was common to see her being chauffeured down the avenue in this car decades after the car had gone out of style. A group that included columnist Henry Clune brought the car back to Rochester after Allen's death. It is now on display at the Rochester Museum and Science Center.

A house on the south side of Elm Street undergoes repairs in June 1900. This was a semiresidential area between East and Main where McCurdys and Midtown Plaza would later be built. Noted Rochester architect Claude Bragdon recalled in his *Reminiscences of Rochester*, published by the Rochester Historical Society, "Though trade already menaced the quiet of East Avenue where it joins Main [Street], the dignified old houses presented an unbroken front like Napoleon's Old Guard, which 'dies, but never surrenders.' " (Courtesy Rochester Public Library Local History Division.)

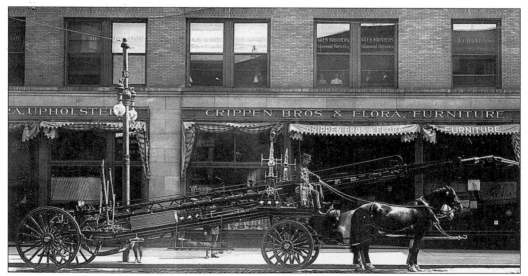

A horse-drawn hook-and-ladder truck stands in front of the Cutler building, at 42 East Avenue and Stillson Street. Former mayor and architect James G. Cutler designed the building, constructed in 1896. (Courtesy Rochester Public Library Local History Division.)

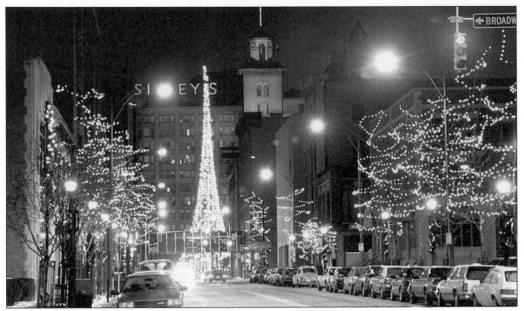

Christmas lights cast a shimmering wintry glow across East Avenue's business district in this 1988 image. The view looks northwest. The Liberty Pole is strung with lights, and behind it is the much missed Sibleys, whose illuminated roof sign was visible well down the avenue. The tower of the Cutler building can be seen to the left of the Liberty Pole. (Courtesy Rochester Public Library Local History Division.)

The Rochester Gas and Electric headquarters and former Sagamore are prominent in this early-1980s look along the business district. A plan to build a high-rise apartment on the avenue on the corner of Chestnut was approved in 1913. A labor strike and World War I delayed construction. The Sagamore and the RG&E headquarters were not completed until 1921. (Courtesy Rochester Public Library Local History Division.)

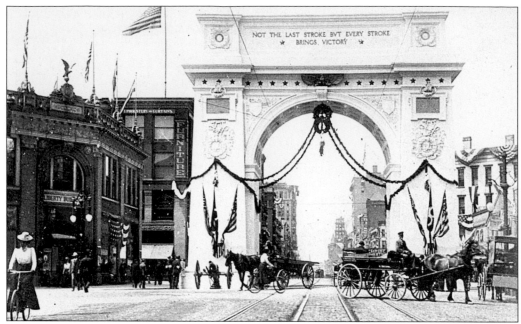

This monumental arch was erected at the intersection of East Main Street and East Avenue to celebrate Gen. Elwell Otis's return from the Spanish-American War. The official day of celebration was June 15, 1900. The arch was designed by noted local architect J. Foster Warner and was obviously very French. It stood 50 feet high and was wide enough to accommodate Main Street's parallel trolley tracks. (Courtesy Rochester Public Library Local History Division.)

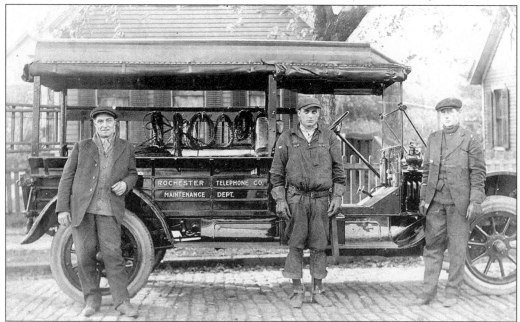

A Rochester Telephone crew poses beside their service truck. Residents along the avenue were anxious to have the new contrivance installed in their homes but did not want unsightly poles and wires out in front of their homes. All poles and wires were therefore run through the backyards. Rochester Telephone was located on Stone Street. (Courtesy Rochester City Hall Photo Lab.)

Three

THE ROCHESTER SEASON

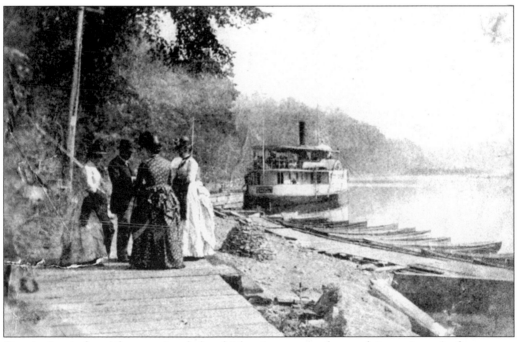

Continuing industrial expansion led to higher incomes and more leisure time. At first, many social events were held in fashionable homes. Later, private clubs developed with their own clubhouses. The provincial and strict Victorian codes of the Third Ward's "old families" were loosened with more defections to East Avenue. In the early days, there was to be no public show of emotion. Circuses, theater, and dancing were looked down on. When social Rochester began changing after the Civil War, young men and women increasingly wanted to do things together. Lawn games, equestrian sports, concerts, and watersports including both sexes increased. Pictured is a group waiting to board the steamship *City of Rochester,* docked at the Glen House. (Courtesy Rochester Public Library Local History Division.)

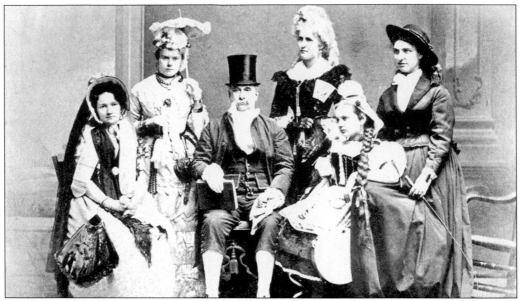

This east-side costume party was held in 1872 at the Freeman Clarke residence on Alexander Street—the home he later donated to the Homeopathic Hospital. These folks are dressed for a small theatrical titled *Widow Bedott*. The Clarkes were known for their lavish entertaining and were featured regularly in society columns. Other entertainments of that day included parlor games such as charades as well as luncheons, socials, dances, readings, lectures, and enjoying stereoviews. (Courtesy Rochester Public Library.)

The clubhouse of the Genesee Valley Club stood on the corner of East and Gibbs and was later replaced with an updated building. The club was incorporated in 1885. Clubhouses presented a delectable challenge to architects, who used them to explore architectural trends. When a membership could not afford to build their own, they would sometimes take over one of East Avenue's ignored mansions.

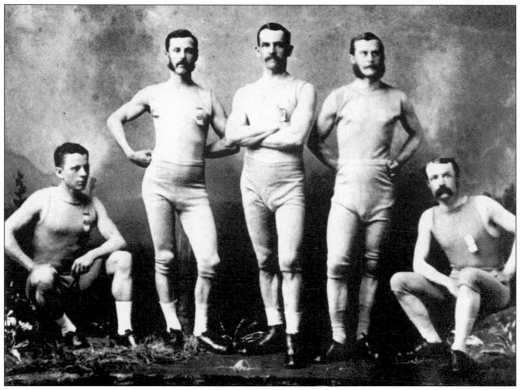

Rochester waterways became increasingly popular as places for recreation. The boys of the Fanchon Club of the Rowing Club of Rochester pose during an outing to Irondequoit Bay in 1873.

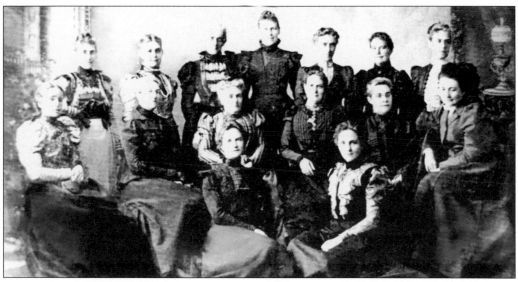

The Wednesday Morning Club was organized in 1890 as a women's literary society. Among the women in this c. 1898 group portrait are Mrs. Rufus Sibley of the famous dry goods store, Mrs. Gannett, and Mrs. Alling. The women discussed novels and poetry and sometimes read their own works. (Courtesy Rochester Public Library Local History Division.)

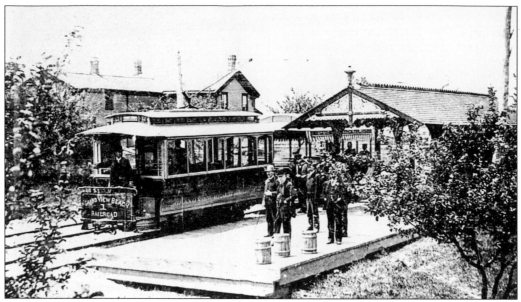

As Rochester's waterways became popular, recreation spots, hotels, cottages, amusement parks, and clubs sprang up along them. Several steam and trolley railroads efficiently transported passengers to these resorts. This early-1890s image shows the Manitou station of the Grand View Beach Railroad. These small railroads disappeared when Rochester's automobile industry started turning out Seldens and Cunninghams. Soon, the well-off were sporting their large touring cars, which they would pack with picnic baskets and swimwear for a day of touring and watersports. (Courtesy Rochester Public Library Local History Division.)

The Bartholomay Cottage Hotel at Charlotte was a favorite stop for a day's outing. Trains would bring thrilled employees out for company picnics. Dining halls were made available for exclusive entertainments. This photograph was taken around the time the hotel was built in 1874. The building burned in 1914. The automobile era, nearly 40 years off, would also open the beautiful Finger Lakes country to recreation. (Courtesy Rochester Public Library Local History Division.)

Visitors to the Glen House enjoy the view of the Lower Falls. The Glen House was located along the bed of the ragged gorge. Guests reached it either by stairs or by an elevator ride. The elevator entrance can be seen in the distance. The Glen House served meals and hosted canoe and boating clubs. Steamboats and private boats docked at the landing to take passengers on trips out on Lake Ontario. A day or week visit to the Glen House was a memorable experience. Part of that had to do with the gorge being damp, smelly, and home to rattlesnakes. The falls, with an adjacent cave as well as the soaring Driving Park Bridge, were certainly spectacular attractions. (Courtesy MLL collection.)

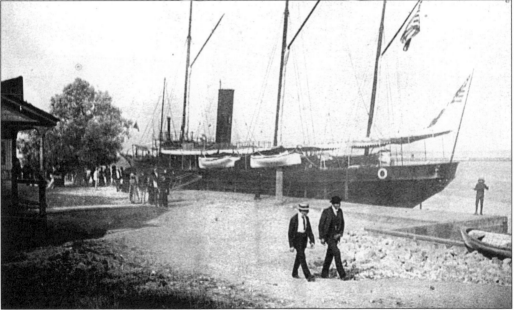

The three-masted steam yacht *Sigma* is moored at the Charlotte pier c. 1889. Rochester's industrial captains relied as much on Great Lake's commerce as they did on railroads, although Rochester never acted like a Great Lake port. Nearby was the Rochester Yacht Club. The craft at the club were of the finest woods, and all brass and nickel fittings were kept polished. Rochester has a colorful maritime history and tradition of distinguished racing. (Courtesy Rochester Public Library Local History Division.)

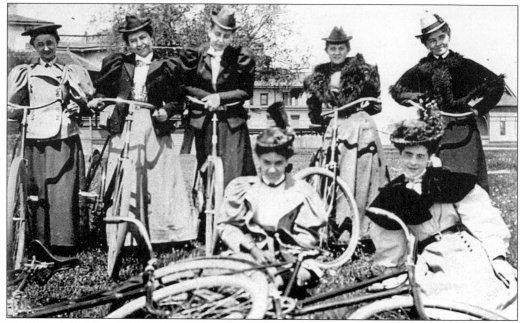

The bicycle era began after the Civil War with a tall-wheeled affair called the velocipede. The safer vehicles these women are posing with came into use in the 1870s. By 1890, the craze had swept through the county. Over 40,000 bicycles would be in use for recreation, business, and transportation. Many bicycle clubs formed. The bicycle was so prized that some East Avenue residents put bike rooms in their homes, where the cherished vehicles could be stored, polished, and adored. (Courtesy Rochester Public Library Local History Division.)

Whenever a club needed an engraved award such as a pin, metal, or plaque, a visit to Starn's Home Jewelry House, at 39 Elm Street, would be forthcoming. (Courtesy Rochester Public Library Local History Division.)

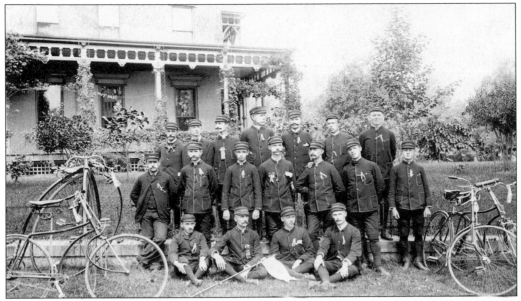

Smartly attired members of the Genesee Bicycle Club pose for a group portrait on August 23, 1890. Note the tall velocipede to the left. They were pretty much passé by this time. The level course of East Avenue provided a good riding surface for young men and women out for an evening spin. Three bike shops opened in the avenue's business section. Hiram Sibley would build an enclosed bicycle rink behind his mansion for his young ones and their friends. It was cyclists who began petitioning the city to pave the avenue. (Courtesy Rochester Public Library Local History Division.)

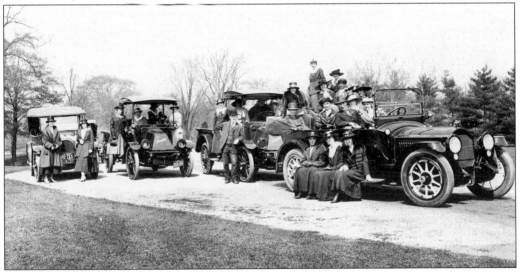

Children of the upper crust were, for the most part, instilled with a sense of civic responsibility from an early age. There was time for fun and then a time for service to home and country. During World War I, the Women's Motor Corps was organized within the Rochester Federation of Women's Clubs. It was used to teach women how to drive trucks during service overseas. Among the members was Urling Sibley, who helped make deliveries of Red Cross food, medicine, and supplies during a deadly influenza outbreak in 1918. (Courtesy Rochester Public Library Local History Division.)

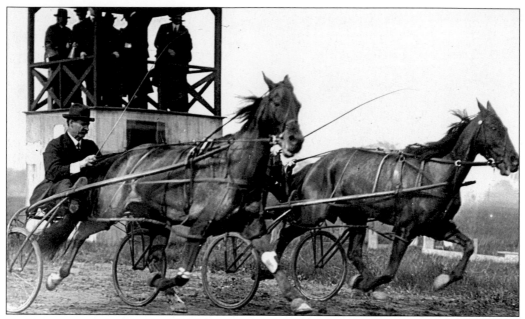

Turf interests were a source of lively socializing for this sports-minded community. Rochester was one of the cities on the Grand Circuit, and every year the best trotters in America came here. The Rochester Driving Park racetrack was a sportsman's paradise. Among the East Avenue men who helped organize it were James Vick, Patrick Barry, Frederick Cook, and A.B. Lamberton. In this c. 1874 view, pacers speed past the judges' stand. (Courtesy Rochester Public Library Local History Division.)

The Genesee Valley Club moved into its new East Avenue clubhouse in 1889. The club had spent the four previous years in the old Jonathan Child mansion on Washington Street in the Third Ward. The Rochester Club had left the Third Ward for the lower avenue in 1888.

East Avenue's scenic eight-mile course, from Pittsford to Rochester's downtown, takes it past two country clubs. The 150-acre Country Club of Rochester, one of the oldest in America, was established in 1895. Mrs. Gannett recalled in 1934, when this picture was taken, "[The club] in my younger days was great fun. Reached by sleigh in the winter and interurban trolley or carriage in the summer, a trip to the Country Club for tobogganing, skating or golf was quite an adventure." Oak Hill Country Club was incorporated in 1901 along the Genesee River and relocated to a 355-acre farm in Pittsford in 1921. It is among the greatest courses in the world, having hosted the most prestigious events in the sport.

Horses were increasingly relegated to pleasure, rather than necessity as the auto age took over. In 1900, the Regas Vehicle Company opened a showroom on the lower avenue, where it sold electric cars. Residents of the avenue could not resist the new invention, but they did not hasten to turn out their coachmen and stable hands. Their prized horses and elegant carriages remained status symbols. A pretty young lady is about to take a horse on to a bridle path. Local parks cut trails and built arenas for equestrian competitions. The tradition continues today as even more stables provide boarding, riding lessons, and shows.

Court Street was connected to the lower avenue's business section via Union Street and was used by residents wanting service from either the Lehigh Valley or Erie Railroads. The Lehigh Valley depot is in the center of the image. The Erie depot is at the far end of the bridge. The

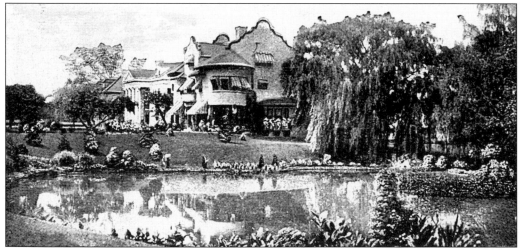

Some estates took on the features of private resorts. Willow Pond was built around a pond lined with massive willow trees. Charles Brown owned the estate at 1500 East Avenue and developed it into an inviting park where the wealthy could hobnob during the Rochester season. A small island was connected to the main yard by a picturesque bridge. The estate was the scene of weddings, concerts, boating, swimming, and fishing. As the grand days faded, the condition of the estate declined. The city declared the pond a possible hazard and filled it in 1955.

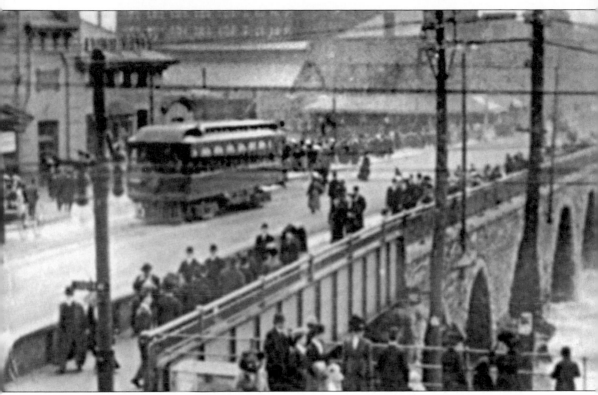

Court Street Bridge spans the Genesee River and Erie Canal in this 1890s image. Two interurbans on the Rochester, Syracuse and Eastern Railway, having just left the Exchange Street terminal, are headed for Syracuse.

Mrs. Alvah Strong shows off her Oldsmobile sedan in front of the Strong mansion, on Allens Creek Road. The home was built by Mrs. Strong's father-in-law, Henry Alvah Strong, the first president of Kodak. The family later sold it to Homer and Margaret Strong—a possible distant relation. Margaret Woodbury Strong was the originator of the Strong Museum, and this house is usually associated with her. This picture was used in a 1934 advertisement for Fincher Motors, at 18 South Union Street. The Strongs were among Rochester's greatest benefactors.

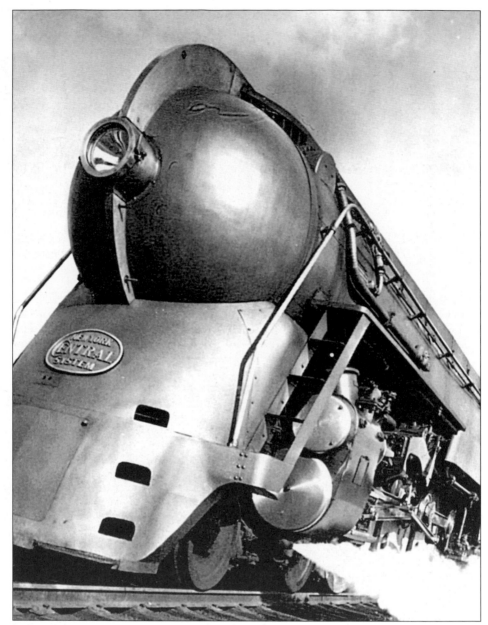

Rochester was a stop on what was considered the greatest train in the world, New York Central's *Twentieth Century Limited*. Bold J3a Hudson locomotives rolled their streamlined passenger cars to our famous Claude Bragdon–designed station. The *Limited* ran between New York City and Chicago. Only passengers of means could afford it. African Americans employed by the railroad sometimes raised their children to work on the *Limited*. They took enormous pride in the food they served and their attention to every detail. Everything about the train was exquisite—its silverware, napkins, silk tablecloths, and outstanding service. Employees sometimes served three generations of families who used the train. Porters welcomed newlyweds aboard and then came to know the birthdays of their children. Through wars and depressions, New York Central's muscular "Great Steel Fleet," powered into the future with faith in America's might. Those on East Avenue missed no opportunity to ride the great train.

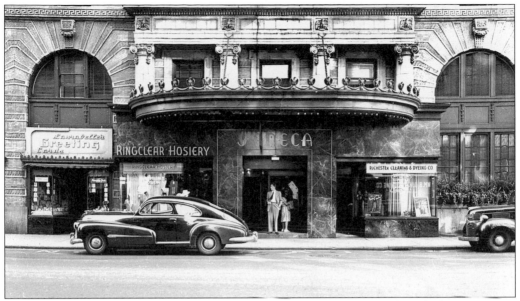

An era of unparalleled style and design filled our city with a rich luster during the 1930s and 1940s. Everything from cars to clothes to architecture had a slick elegance that today's designers go back to for inspiration. The Seneca Hotel was almost directly behind its competition, the Sagamore. Those arriving in Rochester on the *Twentieth Century Limited* would often be taxied to the Seneca. (Courtesy Rochester Public Library Local History Division.)

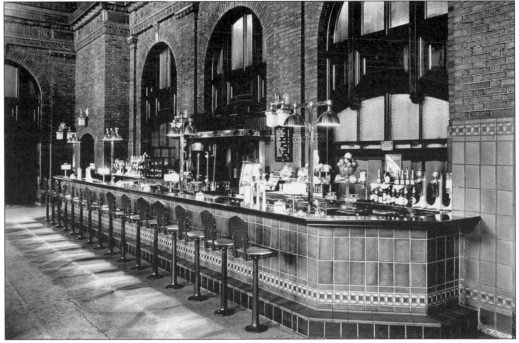

The lunch counter of Rochester's New York Central station captures the beauty of that stylish era in a photograph by Walter D. Towne. The station, designed by noted local architect Claude Bragdon, opened for service in 1915. Some of Rochester's industrialists had their own passenger cars. (Courtesy Rochester Public Library Local History Division.)

The Rochester season had endless attractions and events to satisfy the restless. The pull of the lake, with its watersports, sleepy hamlets, vistas of orchards, and romantic back roads, was irresistible. Grand tours of Europe that could last a summer were much anticipated, but others felt that vistas such as this, from an eminence above Irondequoit Bay, rivaled the views at any European lake.

Corbett's Glen is a romantic setting along Allen's Creek that is richly endowed with natural and man-made beauty. The enormous Rochester, Syracuse and Eastern bridge spans the creek, which tumbles over small falls at the end of the arch. It was a trysting place and picnic spot in the old days, when it was reached by a short carriage ride from the avenue. The creek meanders through a scenic glen before disappearing into woodlands. The glen was once a favorite picnic spot.

Four

THE GRAND APPROACH

The envious and outright jealous tend to spurn discussions of how the elite lived, but it is noteworthy that Rochester's wealthy not only brought beauty and grace to this city by transforming an old road into one of the grandest avenues in America but likewise provided those same envious folk with hospitals, schools, museums, and jobs. Rochester had many successful people who gave the city national prominence. Among the earliest were those who stumbled into Rochesterville with little more than the clothes they wore. A spirit of invention gave Rochester the distinction of registering more patents than any other city in America. The social aristocracy made sure public buildings reflected unparalleled civic grandeur. They spent fortunes to beautify their homes and city. Nationally known architects satisfied the city's demand for street after street of lovely homes. Pictured is the George Thompson house, at 546 East Avenue. (Courtesy Landmark Society of Western New York.)

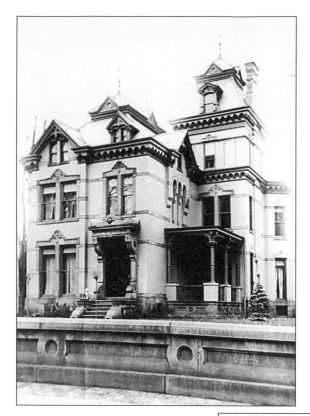

It is not known who the architect for the George Thompson house was, but it may have been Charles Coots, who also designed the Western House of Refuge, a project in which Thompson was the contractor. This monumental residence was built of brick c. 1876. The exterior was accented with horizontal stone belt courses. The foundation was built of red Medina sandstone. The main house was three and a half stories and had a three-bay facade. This photograph was taken c. 1916. (Courtesy Landmark Society of Western New York.)

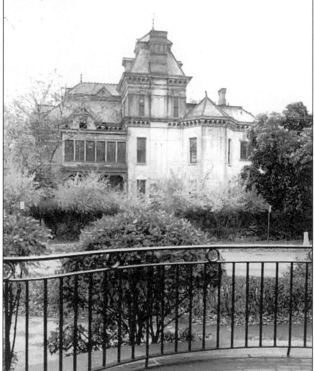

The massiveness of the Thompson house is evident in this view from the backyard. George Thompson was a successful contractor who was responsible for laying miles of railroad track in western New York as well as building numerous railroad structures, including Rochester's New York Central train house. He also built the Monroe County Poor House and the Female Division of the Western House of Refuge. The Thompsons lived here with their two adopted children. This is from a series of photographs taken on October 16, 1966, by Paul L. and Sally L. Gordon for the Historic American Buildings Survey (HABS).

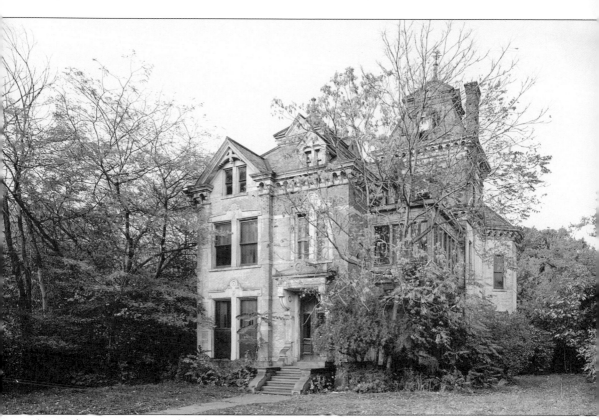

As a sad overgrown ruin, the Thompson house projects a sense of mystery in this photograph, taken by Paul L. and Sally L. Gordon on October 16, 1966. The mansion had been converted to apartments and later abandoned. It was demolished a short time later. A number of East Avenue mansions became worthless wrecks. Most had been built before income taxes, when owners could afford live-in servants. The children of those who built them did not always want them, preferring smaller, more manageable homes. The demolition of this house ignited passions that led preservation groups to resist further destruction.

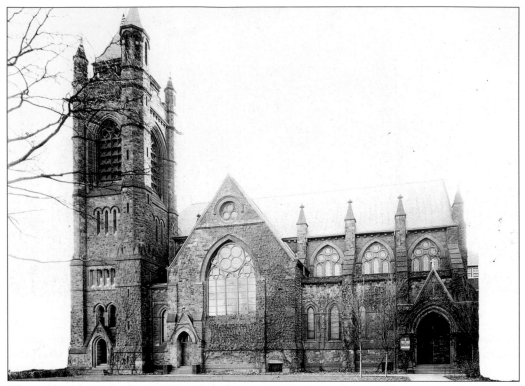

Christ Church was built in 1892 within the avenue's business district. The congregation formed in 1855. The tower for this English Gothic building was completed in 1903. (Courtesy Rochester Public Library Local History Division.)

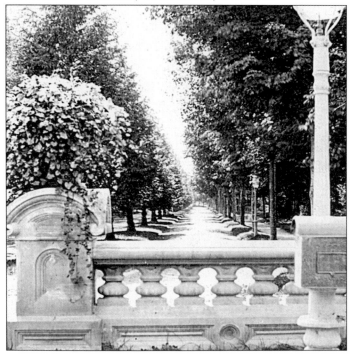

This *c.* 1870s view captures the tranquility of Arnold Park. The avenue and its side streets were resplendent with a vast range of flowers, shrubs, and trees easily attained from nearby nurseries. Some copper beech trees, planted in the 1870s, are with us today, having grown so massive they nearly hide the houses behind them.

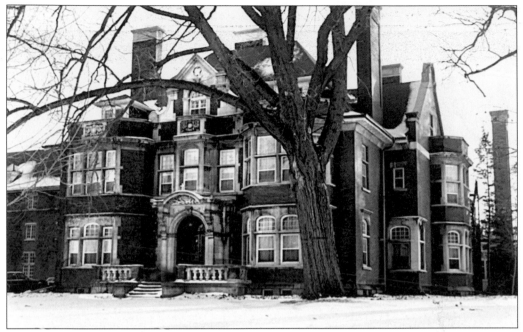

J. Foster Warner designed this mansion for Henry Alvah Strong and his family. Strong formed a partnership with George Eastman in the fledgling days of the Eastman Dry Plate Company (later Eastman Kodak). The Strongs financed a third of the construction costs of Strong Memorial Hospital and contributed heavily to the University of Rochester and Red Cross. The house features curvilinear gables, massive front bays, roof embellishments, and a stone front entrance. The Strongs later built the massive Italian villa mansion on Allens Creek Road.

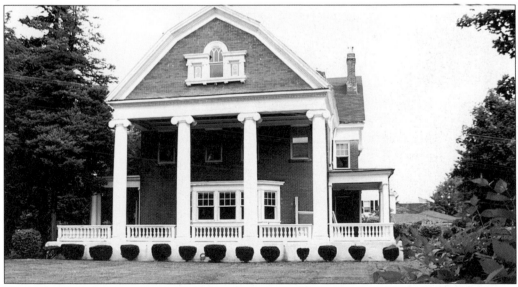

This unique residence was built c. 1905 on the corner of East Avenue and East Boulevard for Mr. and Mrs. Frederick J. Smythe. Its massive roof rests on four Ionic columns and is one of the more distinct porticoes in the neighborhood. By 1928, Otto and Flora Rohr acquired the property. Otto was president of the Stecher Lithographic Company (now Village Gate), a large industry on North Goodman. In 1955, the residence was converted into apartments at a cost of $35,000.

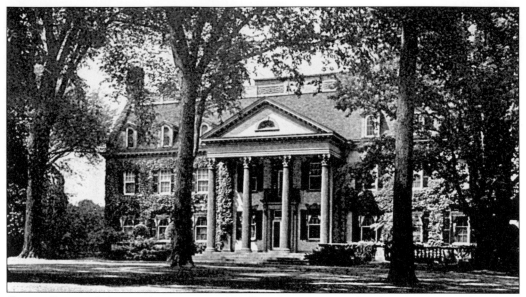

George Eastman's baronial mansion at 900 East Avenue, completed in 1905, introduced the Eastman era to the avenue. The 49-room mansion was designed by the New York firm of McKim, Mead and White with assistance from local architect J. Foster Warner. In 1919, Eastman had the entire rear part of the house cut and moved back to enlarge the music room. The four-acre estate extends from East Avenue to University Avenue and now houses the restored mansion, the International Museum of Photography, and Dryden Theater.

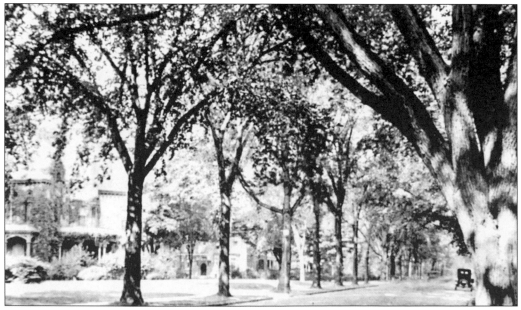

This is the avenue George Eastman enjoyed in the 1920s, a delightful environment shaded beneath a canopy of mature elms. During a slower-paced era, gardeners tended landscapes, nannies pushed strollers, and neighbors visited, although burdened with nightly obligations of dinners, theater, and charitable events. Continuous broad lawns created a parklike setting. There were vistas of small groves, aster trails, peony beds, entrances draped with flowering wisteria, and shadowy solitudes that evoked intimate feelings in even the stoutest soul.

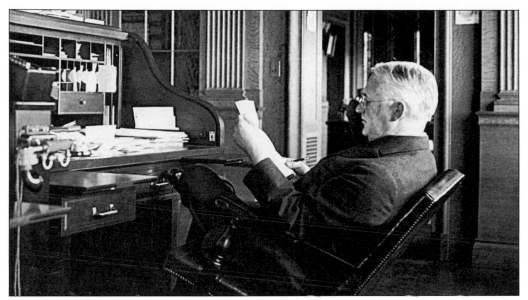

George Eastman, seen in his library, brought some of the greatest figures of his time to this house. Although 900 East Avenue was Rochester's most famous address, Eastman's influence never made it fully "Eastman Avenue." The traditions of the avenue had preceded him. They went back to the first mansions put up by the Sibleys, Ericksons, Bissels, Boodys, and Smiths. It was nonetheless a blow to the avenue when Eastman, fearful of a degenerative illness and convinced his work was done, took his life on March 13, 1932. Rochesterians were shocked, and stillness lingered throughout the city for months.

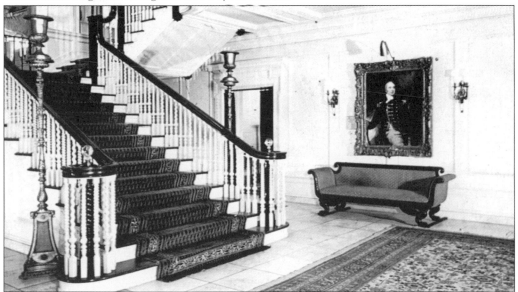

Eastman's grand staircase was at the center of thrilling entertainments. George Eastman regularly hosted concerts using orchestras or his large pipe organ. Other homes had large organs as well, but an invitation to hear Eastman's was an honor not to be ignored. In fact, it was getting harder for other noted families on the avenue to match Eastman's level of entertaining. In 1913, he sent out 1,200 invitations to his gala New Year's Eve party. Those who hosted such parties on the avenue were a bit miffed when Eastman's invitations were given preference over theirs.

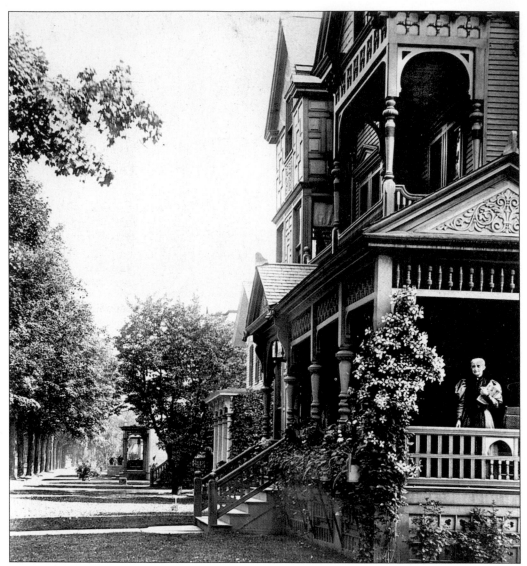

George Eastman lived at this Arnold Park house from 1890 to 1894. His mother, Maria Kilbourn Eastman, is on the porch. The home remains, having been modified 40 years later.

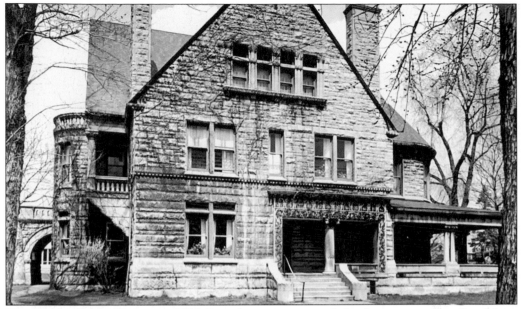

The Wilson Soule House, at 1050 East Avenue, is one of the finest examples of architect J. Foster Warner's work. Built in the 1880s at a time when America still emulated Europe's art, music, and architecture, this remarkable achievement represented a move toward a more defined American approach to design. George Eastman and his mother lived here while his mansion up the avenue was being built. (Photograph by Hans Padelt, courtesy Landmark Society of Western New York.)

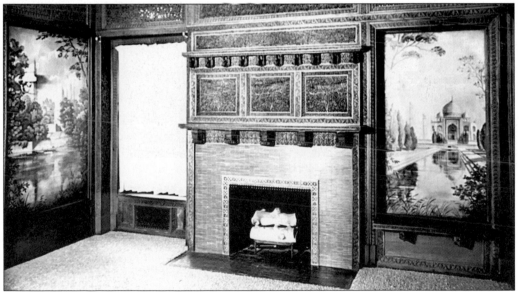

Fashionable Gilded Age homes often featured a richly detailed nook like the Teak Room in the Wilson Soule House. The inset canvas panels have oriental scenes painted in sepia. Nearly every square inch of the nook (including the ceiling) is decorated with intricately carved wood, fabric, and gold leaf. The congregation of neighboring Asbury Methodist Church slated the house for demolition. They realized its historic significance and adapted it to their needs. (Photograph by "the Walrus," courtesy Landmark Society of Western New York.)

Silent screen star Louise Brooks remains a film legend after her death in 1985. She was brought to Rochester to work with archivists at the International Museum of Photography. She stayed at the Treadway Inn and later rented a bleak apartment on Goodman Street. This "impossible person," with her demanding ways, insecurities, addictions, compassion, and intellect, was tended to by a loving group of friends who recognized her talent and lamented her failed career. She could repel them with her nasty outbursts, but they always came back to her. Any star of consequence visiting Rochester to receive a "Georgie" award at the museum or to perform at a local venue sought an audience with her, even if it was for a few minutes at her bedside. Admired as one of the greatest beauties of all time, she was also a skilled writer. She assembled her film journals into a stirring memoir, *Lulu in Hollywood*.

The Cogswell-Bently House, at 7 Prince Street, features beautiful detailing. The property backs up to the original Hiram Sibley estate. There was a stable behind where Hildegarde and James Sibley Watson Jr. produced two films of note in the late 1920s. The films continue to be studied by film students. This 1972 photograph was taken by "the Walrus." (Courtesy Landmark Society of Western New York.)

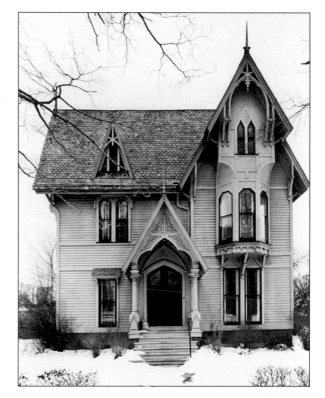

A postcard stamped 1907 captures the tranquility of the avenue. Automobiles were just coming in, but the horse still ruled the road. Two policemen patrolled regularly on bikes, making sure cyclists in particular did not exceed the six-mile-per-hour speed limit. The last carriage, that of Frederica Elwood, disappeared from the avenue in 1915. Beneath the canopy of elms, passersby could look up the broad lawns at majestic houses still in the full luster of their era, before sweeping urban forces arrived to threaten them.

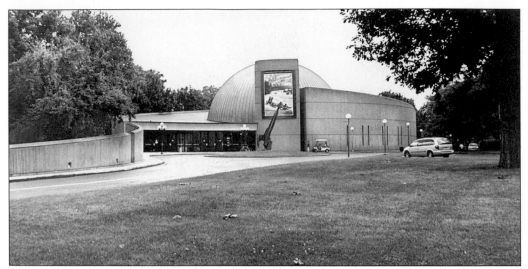

A bold design that does not seem at odds with the diverse architectural legacy of the avenue is Strasenburgh Planetarium, part of the Rochester Museum and Science Center complex. The domed structure was built on the Bausch property. As mansions became too expensive for individual families, the need to maintain a tax base dictated changes. Many homes were converted to high-end apartments or taken over by churches, institutions, or small businesses. Strict zoning and restrictions by preservation organizations have kept the visual and historic integrity of the district intact while allowing for daring and inventive designs such as this.

The Rochester Museum and Science Center anchors the cultural heritage of the avenue. Unlike many cities that lost their grand avenues to development, Rochester activists fought, and largely succeeded, in maintaining their most spectacular residential street. Usually older homes were donated for commendable uses such as schools, nursing homes, religious institutions, and community-related headquarters. The museum complex includes a portion of the original Whitney house, on Goodman Street.

Some mansions were replaced with apartment buildings. In 1943, the city council, realizing fewer mansions could be maintained as single-family residences, adopted the East Avenue Plan, developed by the Rochester Society of Architects. The district was changed to a broader F-Residential zone, which reduced the soaring land values, thus allowing residents who wished to stay to do so. Restrictions were enforced on new and existing structures. Additionally, the city would acquire unwanted properties, clear the lots, and establish parks so the tradition of a lush entrance to the city would be maintained.

Asbury First Methodist Church, at 1050 East Avenue, was dedicated in 1955. The 1950s were a time of change for the avenue. A study showed that only 48 homes between Alexander and Colby Streets were still used as single-family residences. Renters in old homes that were converted to apartments complained of substandard conditions. However, matters would slowly improve. By 1960, most residents were new with only a few old families left. Congregations tended to remain loyal to their proud old avenue churches and willingly made the trip in for services even if from a distant suburb.

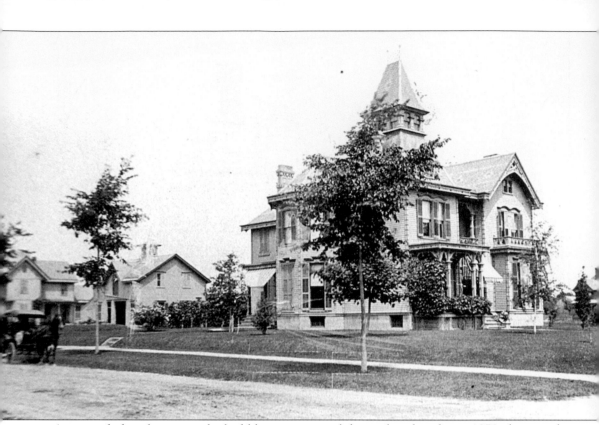

A sense of what the avenue looked like in more rural days is found in this *c.* 1870 photograph of the McMillan house, on the corner of East Avenue and Merriman Street. The carriage house was later converted to an apartment. The home survives with some minor changes. When the photograph was taken, mansions started going up at a steady clip. Road improvements were progressing. Medina stone curbing had been installed in 1860. Improved street gutters paved with cobblestones were installed. Residents paid for flagstone sidewalks (visible above). Omnibuses provided service to the city. The road from Goodman to downtown had been graded and covered with a layer of crushed stone, but the old plank road from Goodman to Brighton was deteriorating. The original horse chestnut trees planted by early resident Josiah Bissell did not survive long, so the Shade Tree Association, formed in 1852 to improve the street's beauty, planted elms evenly spaced along both sides and surrounded them with slats so horses could not chew the bark. (Courtesy Landmark Society of Western New York.)

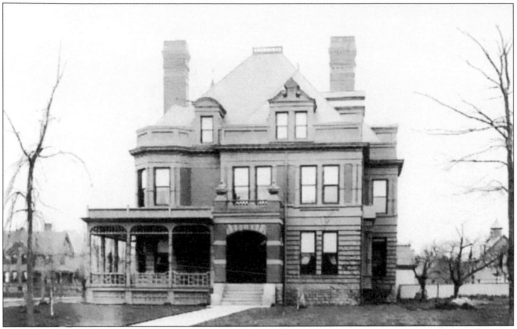

This beautiful residence with elaborate roof and chimney details was built for Henry Mason Ellsworth and his family. It still graces the southwest corner of Vick Park A and East Avenue. Ellsworth was a partner in Ellsworth and Grant, contractors who built commercial and railroad buildings during Rochester's railroad boom after the Civil War. (Courtesy Rochester Public Library Local History Division.)

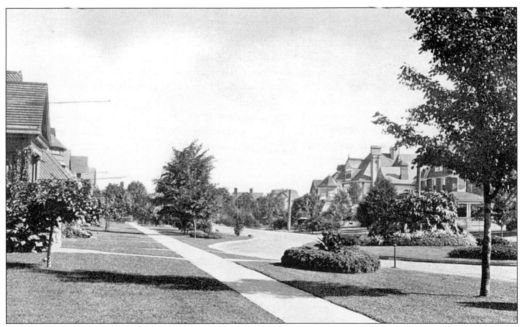

Portsmouth Terrace is lined with a number of rather large Victorians. The effort to make residents feel they live in a kind of idyllic park was achieved, in part, by running lawns in a continuous line to create visual unity.

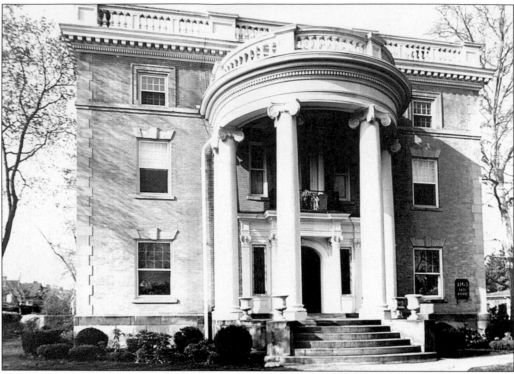

This majestic home looked much different in its original form (see the photograph below). Designed by Andrew Jackson Warner for prominent nurseryman Charles Barry of Ellwanger and Barry Nursery, the original 1892 home was extensively remodeled in 1920 by the architect's son J. Foster Warner. (Courtesy Landmark Society of Western New York.)

The Barry house is pictured here in its original form. Perhaps architect A.J. Warner was influenced by the three large block-styled Greek Revivals up the road—the Pitkin, Smith, and Perkin homes. The jury is still out on this one. Not every mansion was a masterpiece. Some think this was a unique, forward-looking design. Others think it looked like a parking garage. (Courtesy Landmark Society of Western New York.)

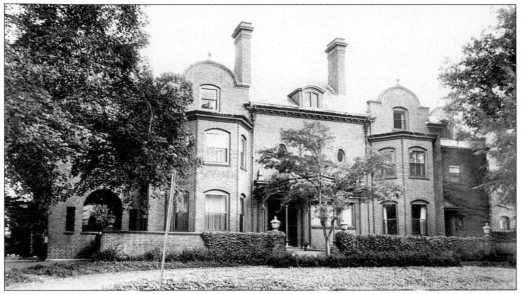

Architect Claude Bragdon created this masterwork on the corner of East Avenue and Berkeley Street for George Buell and family. Buell was a wholesale grocer who had built several beautiful homes in the city, including one in Livingston Park. The brick residence creates a medieval mood with its curvilinear gable walls, arched brick windows, and Jacobean elements. The former residence now houses condominiums. (Courtesy Landmark Society of Western New York.)

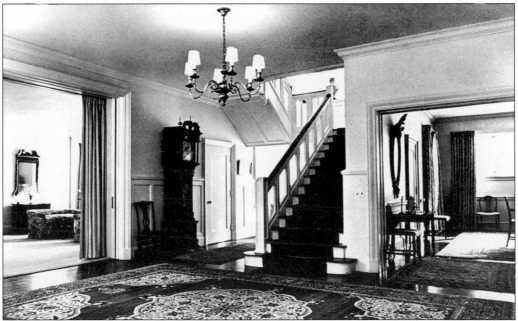

Bragdon's interiors tended to be clean, spacious, and uncluttered, as evidenced in the Buell House entrance hall. At the height of building, there had to be at least a dozen Rochester architects taking commissions. Although work was plentiful, there was still competition because the affluent were bringing in noted designers from Boston, New York, and Chicago. Those who chose Bragdon to design their residence were seldom disappointed. (Courtesy Landmark Society of Western New York.)

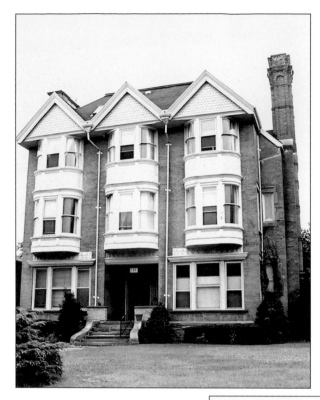

This unusual three-bay Queen Anne home at 303 East Avenue was built c. 1883 for Alexander and Eunice Lamberton. Architect Harvey Ellis designed many distinct homes and commercial structures in the city. He had a reputation for being difficult, unreliable, and a "drunken genius." The home, converted to multiple residences, remains a noted feature of the street. (Courtesy Rochester Public Library Local History Division.)

Alexander Byron Lamberton commissioned this residence. An Irish immigrant, Lamberton attended the University of Rochester and then left for business and ministerial pursuits. He returned to Rochester in 1864 and started a successful lumberyard at Exchange and Spring Streets on the site of the noted Rochester House hostelry. He oversaw the building of the Exchange Street Swing Bridge, the only one of its kind. His interest in public affairs and love of the outdoors landed him on the parks commission, where he worked with talented landscape architects such as Frederick Law Olmsted. He brought Rochester some of the most beautiful parks in the country. The Lamberton Conservatory was named in honor of "the Father of Rochester Parks."

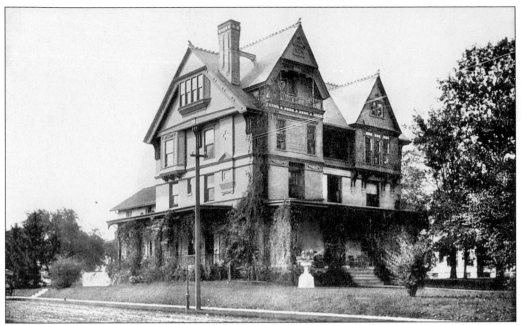

This lovely residence stood at 297 East Avenue and was home to one of Rochester's most accomplished and influential citizens, Samuel Wilder. He was responsible for three of Rochester's architectural gems, including the landmark Wilder Building (at the Four Corners), Rochester's first skyscraper when built in 1888. Wilder helped institute three banks and used his expertise and resources to help establish Rochester General Hospital.

A contemporary streetscape shows how well the avenue has been maintained. The Lamberton house is to the right. The third house down is the Ellsworth residence, believed to have been designed by Ellis as well.

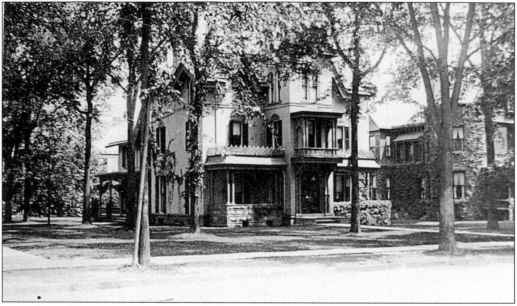

The Theobald Meyer residence, at 268 East Avenue, is pictured in 1896. Meyer was a partner in the clothing firm Garson, Meyer and Company. Note the condition of this house on page 99.

The 1918 Armistice Day night parade is under way on the avenue. America had been a rather average nation, overshadowed by the decaying glory of Europe. Foreign upheavals at the turn of the century put the nation on the road to greatness. Rochester's industries were quick to meet the demands of this emerging superpower. East Avenue was a site of community receptions and rallying point for new civic and national goals. (Courtesy Rochester Public Library Local History Division.)

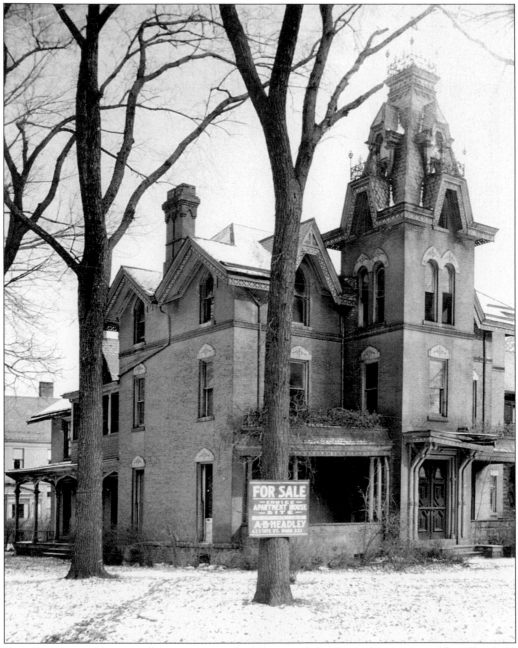

East Avenue was not totally immune to the ravages of the Great Depression. The Theobald Meyer residence certainly fell on hard times, as seen in this Depression-era photograph. Untended for years, the entrance and porch roofs have decayed. The For Sale sign suggests it is a good apartment house site. It is unclear whether that means the house would make a good apartment or that it should be replaced with a new building. According the Blake McKelvey's East Avenue treatise, the city, eager to get some tax revenues from abandoned sites, amended its zoning ordinance in 1932 to allow construction of apartment buildings from Alexander Street to Upton Park. At this time, the city also replaced the globe streetlights with taller ones and repaved the road to retain the area's beauty. (Courtesy Landmark Society of Western New York.)

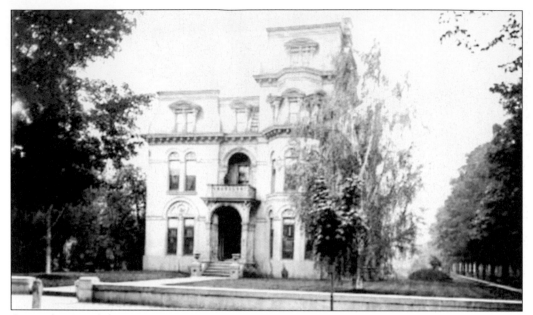

Certainly one of the most attractive East Avenue residences was that of Frederick and Barbara Cook. Designed by A.J. Warner and completed c. 1876, it stood on the southeast corner of East and Arnold Park. This showplace had a third-floor ballroom where Prince Henry of Prussia once danced. The reigning elite, including dowagers, belles, and Genesee Valley gentry, sought invitations to the sumptuous entertainments held here. The downstairs featured wall-length mirrors and rich walnut paneling. Pipes ran from casks in the basement wine cellar to a hand spigot upstairs. The outside had iron grill cresting around the roof. The house came down in 1934.

Frederick Cook was a German immigrant who had to make his way in the world when he was only 15. He came to Rochester in 1852 and quickly started on a course that would make him one of the city's most prominent citizens. He served as secretary of state under Gov. David B. Hill. He built Cook's Opera House. Cook had been a train conductor in earlier years and later invested heavily in the Pullman Company. He and his second wife, Barbara, were civic spirited and broadly philanthropic.

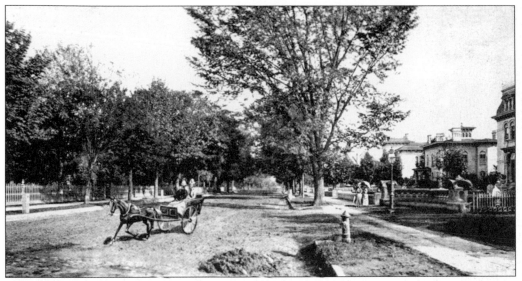

The 1880s were a colorful time. The sound of hoof-beats on the macadam surfaced road was pleasant except when young men, out to exercise their prize horses at dusk, couldn't resist a race when a friend came up. Residents complained about the dust this stirred so regular sprinkling was insisted upon. In winter, brightly colored sleighs with colorful plumes traversed the road with matrons headed for church or other social obligations. Children would squeal as their young dashing fathers cracked buggy whips, sending their large sleighs racing down the snowy road. The Cook residence is to the right in this picture.

A stereoview of the Arnold Park gates suggests an invitation to an idyllic park. At night, under the hissing glow of gas street lamps, neighbors would take to the sidewalks to visit those on their porches. Piano or violin music would drift from the open windows of music rooms. Gardens would exhale their evening fragrances and neighbors would break from their light conversations beside ornate fences when the bells of the Third Presbyterian Church joined with the distant convent bells at Sacred Heart Chapel in ringing out the hour.

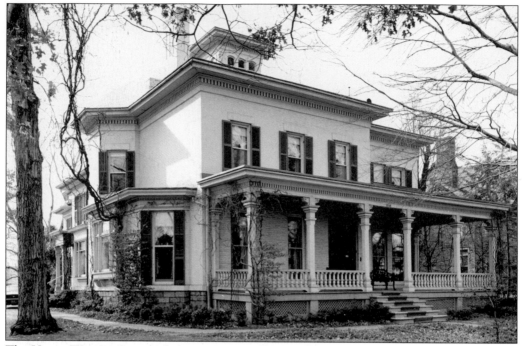

The Harris-Watson-Spencer home was originally 383 East Avenue and later changed to 1005 East Avenue. The gardens are among Rochester's oldest and are regarded as some of the finest in Monroe County. The original house was built by Edward Harris in 1867. A copper beech tree planted in front in the 1870s matured into a magnificent specimen that now obscures the house from the road. This photograph was taken in 1968 by Hans Padelt.

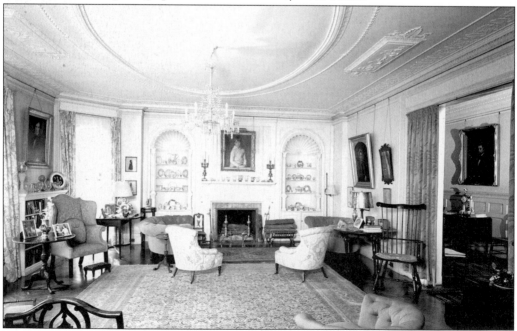

The first-floor drawing room of the Spencer house, pictured in 1968, features elaborate gypsum ceiling decorations, wall niches, and other refined details. (Photograph by Hans Padelt.)

A grand sweeping staircase is the focal point of the Spencer entrance. Superb craftsmanship is apparent throughout the residence. The photograph was taken in 1968 by Hans Padelt.

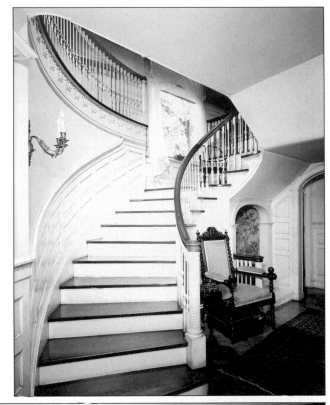

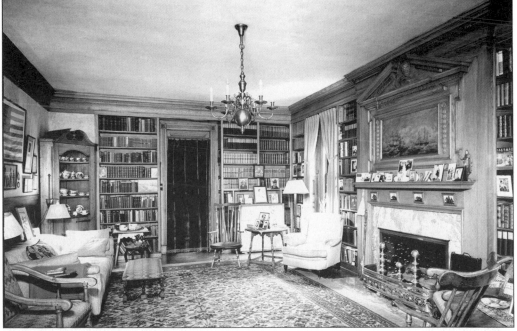

The Spencer library, seen in 1968, was remodeled in 1925. The house was situated along the rural part of the avenue when built in 1867, and this room seems to retain some of the warmness and charm usually found in country estates. (Photograph by Hans Padelt.)

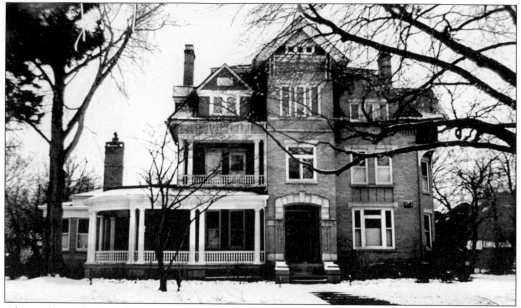

Alexander Miller Lindsay's stylish coach made the daily trip from his East Avenue mansion to his highly successful dry goods store, Sibley, Lindsay and Curr. Where Sibley was a financial genius, Lindsay was a master of merchandising. The home has Scottish baronial elements, particularly in "the great room." The formal gardens were designed to be reminiscent of Lindsay's beloved Scotland. (Courtesy Landmark Society of Western New York.)

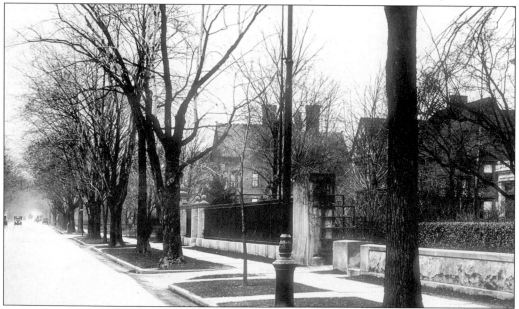

On bleak November days, the avenue could take on brooding tones, reinforcing attitudes held by some "regular folk" toward Rochester's own robber barons. Walking along this wall of stone and iron fencing may have aroused gloomy thoughts about those of the "upper class" who honed their sense of superiority. The upper crust along this and other American grand avenues wanted to advertise their wealth through regal homes but were quick to urge those on the street to "look but stay back." (Courtesy Rochester City Hall Photo Lab.)

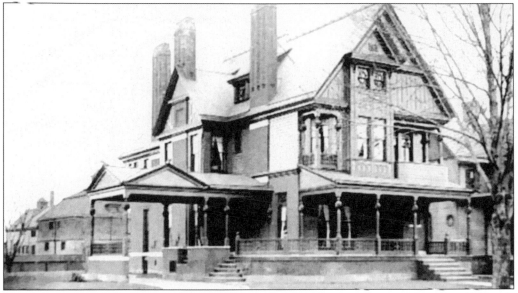

Benjamin and Marilla Chase welcomed friends and associates to their residence at 10 South Goodman near East Avenue. Benjamin was president of the Central Bank, first vice president of Rochester Savings Bank, and director in the Union Bank and Security Trust companies. He was also treasurer of the National Casket Company and directors in Bell Telephone and the Lyceum Theater. He also had time for memberships in the Genesee Valley Club, the Rochester Club, Rochester Whist Club, Caledonia Fishing Club, Keuka Lake Club, and Rochester Yacht Club. No wonder it was written he was a man of "untiring activity." The home was donated to the Rochester Museum and Science Center in 1979 by then owner Mrs. Francis Cunningham.

A traffic signal known as a "silent policeman" was used throughout the city in the early days of motoring. This one was on the corner of East Avenue and Vick Park A. Later, electric traffic lights appeared on posts along the sides of the intersections. Overhead traffic lights eventually replaced them. (Courtesy Rochester City Hall Photo Lab.)

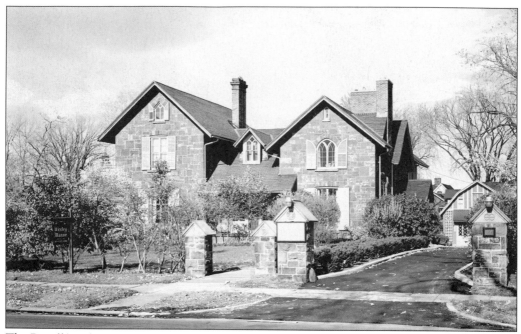

The Bissell residence, at 66 East Avenue, is a house with many stories. It was built from the cut-stone blocks of the first Erie Canal aqueduct. Bissell was active in beautifying the avenue in the 1840s. He planted a double row of horse chestnut trees from his house west to the Liberty Pole. Bissell nailed signs up, renaming East Main to East Avenue. He ran a nursery on the avenue that the owners of the first mansions made good use of. This photograph was taken in 1967. (Photograph by Hans Padelt.)

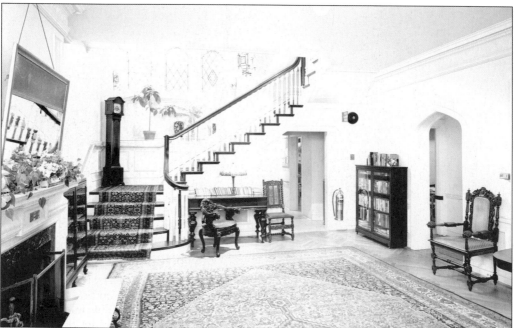

The attractive foyer in the Bissell house features this beautiful staircase. A fireplace on the left kept many visitors warm during winter entertainments. (Photograph by Hans Padelt.)

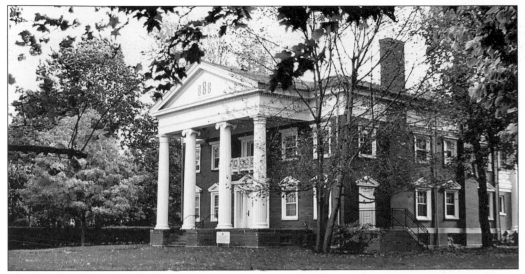

This simple and beautiful structure was built before 1920 as a residence. It is often mistaken as a Greek Revival but is actually a Colonial Revival house. Greek Revivals had their reign in Corn Hill, bringing grace and majesty to that ward. The style was passé when the era of intense mansion construction began on the avenue during the Gilded Age. For over four decades, this former residence has served as a synagogue for the Congregation of Beth Hamedresh-Beth Israel.

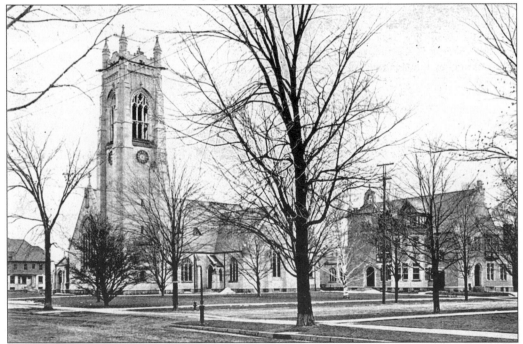

St. Paul's Episcopal Church, at East Avenue and Vick Park B, was designed by the architectural firm of Heins and LaFarge. The parish, organized in 1827, built a church on St. Paul Street in 1830. They moved into their new Gothic Revival church here in 1897. This was at the time when many churches sought the prestige of an East Avenue address. Both Rufus A. and Hiram W. Sibley helped found the new church. An impressive 2,554-pipe organ accompanied the congregation. The parish house can be seen to the right of the church.

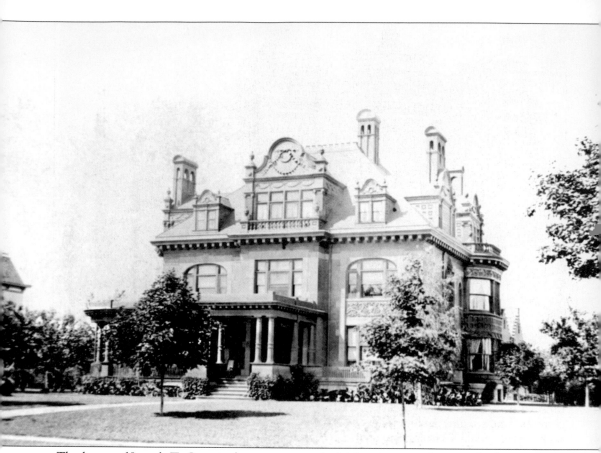

The home of Joseph T. Cunningham represented a high point in architectural achievement in Rochester. It has a baronial quality with its steeply pitched roof, gables, and chimney flourishes. Joseph and his father ran a successful carriage manufactory that later produced exquisite hand-produced automobiles. The factory was on Canal Street near the junction of the Erie and Genesee Valley Canals. At one time, they were the city's largest employer. (Courtesy Landmark Society of Western New York.)

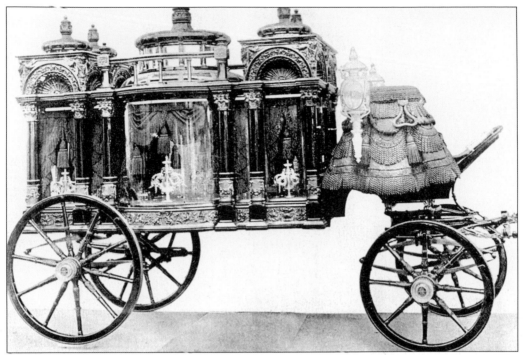

In addition to high-quality carriages, Cunningham manufactured ambulances and hearses. The body was finished in both flat and gloss-black enamel for a soft contrast. The interior was finished in mahogany, and a curved-glass window allowed for viewing of the casket during corteges. The columns and roof embellishments had silver-plated mountings. Even the wheel spokes were carved. Cunningham automobiles were finished inside and out with exotic woods and hand-tooled leathers.

James Cunningham was principal among Rochester's industrialists, running his father's Cunningham and Company, established in 1838. He, along with Bausch, Eastman, Gleason, and others, helped establish New York State as a major industrial power. The legacy of Rochester manufacturing—"Rochester Made Means Quality"—was not just a catch phrase. The city taught the world how to produce the finest optics, cameras, and electronics. Factory machining here was second to none. Beyond that, Sundays on the avenue were made even more gracious by Cunningham's elegant sleighs, phaetons, landaus, and automobiles.

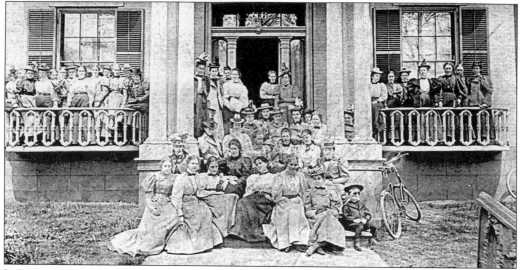

In May 1897, students and teachers of Mrs. Hakes' School posed at the school that had recently moved into this location at 86 East Avenue. The school was organized in 1876 by Martha Cruttenden. She turned the administration of it over to Mrs. L.H. Hakes in 1894. The school closed in 1909. (Courtesy Rochester Public Library Local History Division.)

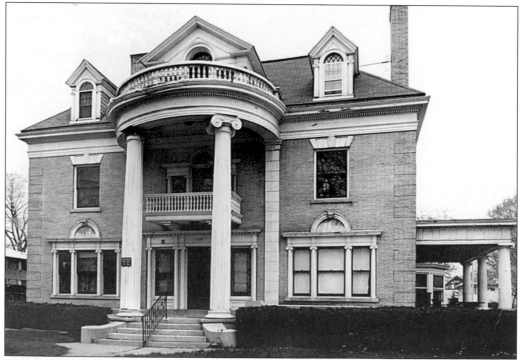

Prominent local figures continued to flock to the avenue up until the 1920s, building handsome residences or taking over older homes of those who preferred the newer semirural streets, such as Sandringham, Ambassador, Council Rock, and Esplanade. The cost of keeping the bigger homes up and the loss of domestic help made old families abandon their majestic mansions. Additionally, their offspring did not want the big old family houses, preferring smaller but equally distinguished ones with updated features.

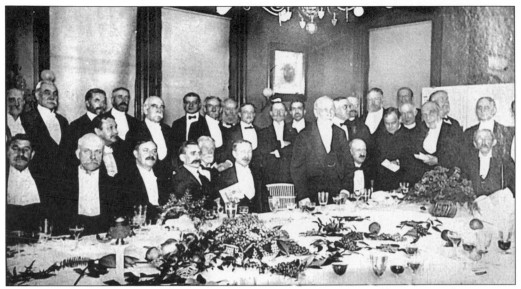

This *c.* 1900 photograph shows a birthday celebration for George Ellwanger at the Genesee Valley Club. Ellwanger is standing in the center. Around him are noted Rochester patricians, including George Eastman and Rush Rhees. The city, in spite of pollution, poverty, violence, and corruption, was still a monument to their success. They poured fortunes into beautifying it. This party most likely included much discussion of civic matters. (Courtesy Rochester Public Library Local History Division.)

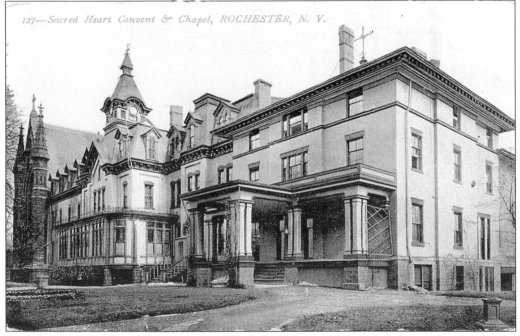

A postcard view postmarked 1910 provides a different perspective of the impressive Sacred Heart Academy's convent and chapel on Prince Street. The academy started in the residence to the right. Neighbors came to enjoy the chiming of the convent bells much as the old Third Warders did the tolling from the Plymouth Congregational Church tower.

The Yates residence was built between Portsmouth Terrace and Granger Place in the 1880s. Frederick Yates was the owner of the Yates Coal Company. Like most homes, there simply had to be elaborate gardens. The avenue's emergence from nurseries already gave it a natural grandeur. Some owners laid their gardens out in squares, others in circles. They were the scene of parties, weddings, concerts, and eulogies when corteges from nearby churches passed. This house was razed in 1944. (Courtesy Rochester Public Library Local History Division.)

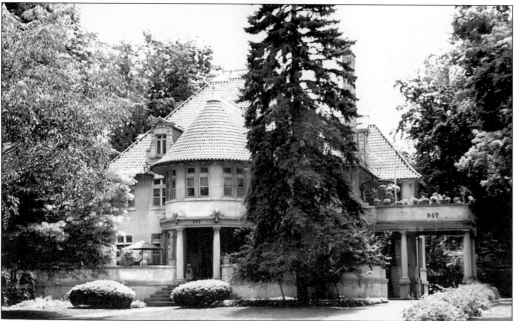

Mature trees surround the majestic Ritter mansion, at 947 East Avenue. Architect Leon Stern used for inspiration a 15th-century manor castle in Bavaria. Frank Ritter, founder of the Ritter Dental Manufacturing Company, moved in with his family in 1907. The Catholic diocese used it from 1915 to 1975 as a bishop's home. It has since been reworked first for apartments and later for condominiums.

112

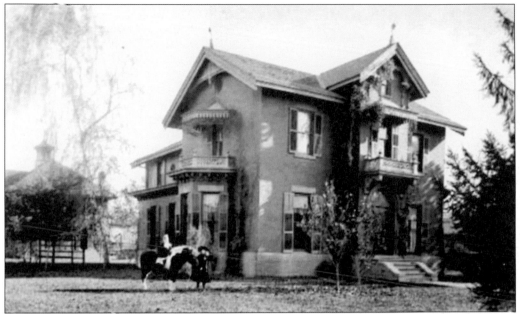

Two children pose with their pony beside the Brewster residence, located on South Union just south of East Avenue. Henry C. Brewster was a banker, chamber of commerce president, and congressman. This photograph appeared in the 1890 publication *Rochester Illustrated*.

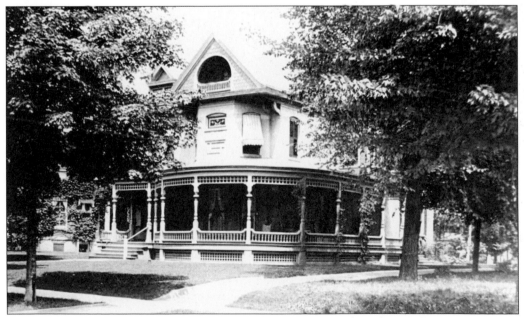

The Cory residence on the avenue is still with us, having been adapted to modern uses. It is well maintained, with the elaborate porch still intact. This images dates from the 1890s.

The Gleason family name is well known to most Rochesterians. Starting from a factory on Mill Street in 1865, they grew Gleason Works into an industry that gave Rochester international notoriety. They were among the avenue's most respected citizens. In the 1920s, Kate Gleason had this rambling Mediterranean residence built on East Avenue near the present St. John Fisher College. (Courtesy East Rochester Municipal Historian Collection.)

Kate Gleason and her brother James took over operations of Gleason Works, the machining industry their father, William, created during the Civil War. Kate's business prowess is legendary. She was involved in all facets of the business—manufacturing, engineering, marketing, and development. Her philanthropic accomplishments are internationally known. France honored her after World War I for her reconstruction efforts. In another project, this remarkable woman designed a model industrial community in East Rochester, using concrete houses that had a European charm.

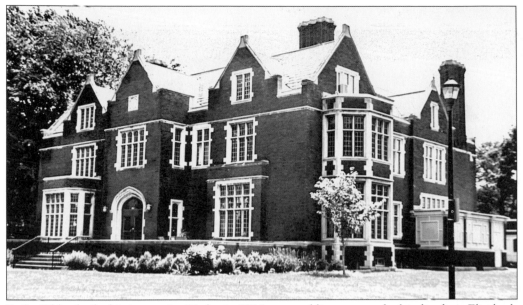

Rufus Sibley built this impressive Tudor in 1913 as a wedding present for his daughter Elizabeth Adams Sibley. Rufus lived across the street and purchased the lot from Alexander Lindsay, his business partner at Sibley, Lindsay and Curr. Five years later, Elizabeth married again, this time to Edwin Allen Stebbins, and they lived here until their deaths in 1954. The large front lawn and formal English details suggest an English country manor. Note the cast-stone details around the doors and windows, the Tudor front entrance, and the gables that rise in a parapet above the slate roof. The Episcopal diocese purchased the house a year after the Stebbinses died.

Among the most famous gardens in the district were those created by noted landscape architect Fletcher Steel for the home of Charlotte Whitney Allen, one of the last grande dames of Rochester society. A daughter of the family associated with the Whitney Flour Milling Company, she led a privileged life from the start. There were grand tours of Europe and Egypt before World War I and later with lifelong friend Clayla Ward. Her Oliver Street home was a wedding present from her parents. She was chauffeured daily in her 1936 Ford Cunningham until her death in the early 1970s. Artists, writers, status seekers, and musicians attended the "chilled glass hour" for cheese flown in from New York City and Charlotte's "very dry" martinis. (Courtesy Landmark Society of Western New York.)

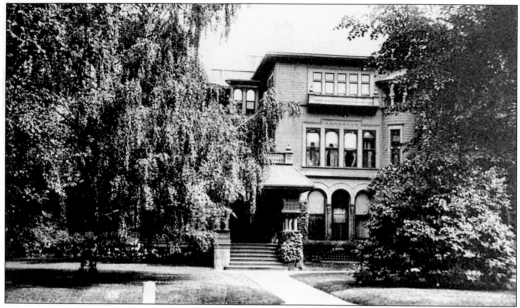

John Fahy was partner with his brother in J. Fahy and Company, a large dry goods store they started as a millinery shop in 1868. The business eventually filled a six-story building on the corner of State, Mill, and Market Streets. John had this house built in the 1890s at 288 East Avenue near Upton Park. Architects, contractors, and artisans were quite busy in the district at that time.

Workers and supervisors take a break from work on the Oxford Street and Monroe Avenue sewer construction project in June 1895. In 1875, a "large, capacious, and durable sewer" had been installed. Blake McKelvey wrote in 1967 that it was made of Copeland cement pipe that was 30 inches in diameter and, at 700 feet, was the longest stretch of sewer pipe yet laid in Rochester. Other improvements included laying gas pipes, water mains, and sewers. (Courtesy Rochester Municipal Archives.)

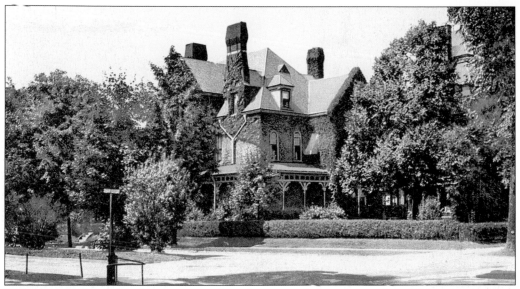

This imposing house, with its steep roofs and massive chimneys, stood at 451 East Avenue on the southwest corner of Sibley Place, across the street from Woodside. It was home to J. Moreau Smith, president of the Rochester Trust and Safety Deposit Company. To the right of the house is the tall tower of 441 East Avenue, home of S.H. Briggs, another banker. Both houses came down in the 1950s and 1960s, before the city designated the avenue a "preservation district."

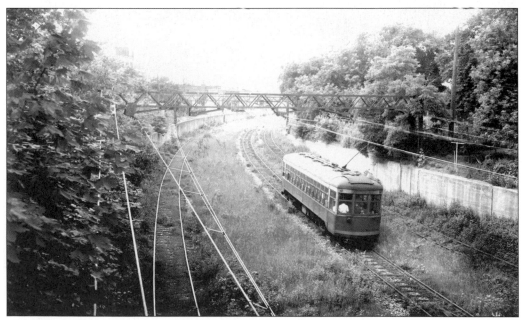

Along the edges of the East Avenue district, the bustle of everyday commerce included noisy transportation. A westbound subway car clatters along the tracks just west of Meigs Street. (Courtesy Rochester Municipal Archives.)

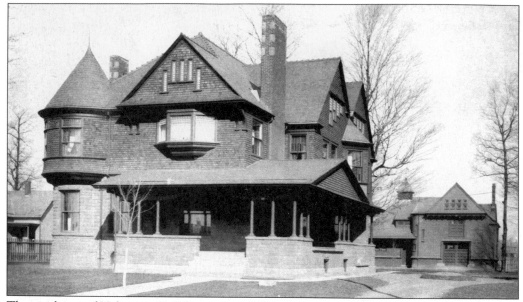

The residence of Valentine F. Whitmore at 170 Park Avenue has a ponderous look offset by a shady, inviting porch. Note the impressive carriage house. Whitmore was a prominent banker.

This is the C.C. Meyer and Son steam sawmill and boatyard. The mill and yard were located along the Erie Canal near the intersection of Monroe and Culver. This was a busy operation, building canal boats and milling lumber for the large homes along the avenue. (Courtesy Rochester Public Library Local History Division.)

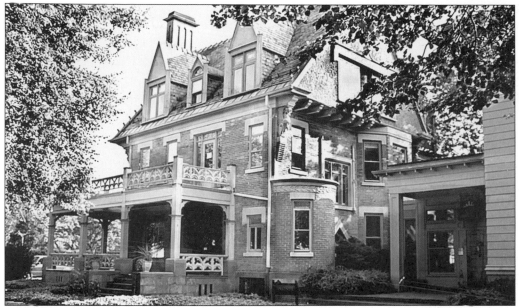

One of the more distinct Queen Anne houses in the neighborhood is 5 Arnold Park. It was a turnkey product built by William McCombs Company in 1881 for Frederick Klein. It came complete with furniture, linens, tableware, towels, and even a stocked icebox. Today, it is part of the Zen Center. A small gallery connects it with 7 Arnold Park, another home incorporated into the Zen Center in 1968.

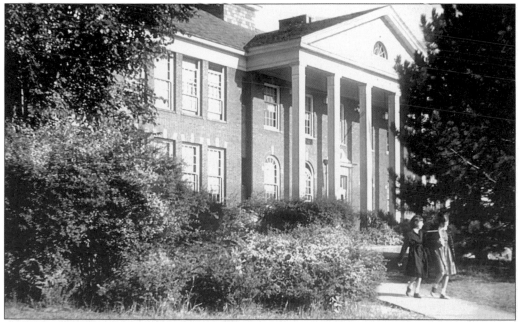

Along its eight-mile course, the avenue passes several learning institutes. Allen's Creek School, pictured here in 1950, started in 1879 in a frame schoolhouse. This building replaced it in 1929. Continuing along the avenue is St. John Fisher, a liberal arts institution. The campus of Nazareth College, founded in 1924, occupies 94 wooded acres nearby in Pittsford. It is a comprehensive college offering liberal arts and sciences. (Courtesy Town of Brighton.)

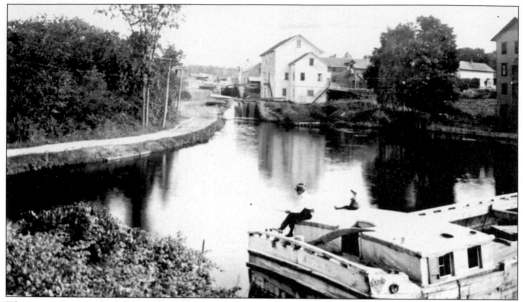

The top of a canal packet is a perfect spot for a man and boy to fish. This tranquil *c.* 1900 image captures the serenity and laziness of a summer's day along the canal as it passes through Perinton. There are some mills in the distance. (Courtesy Perinton Municipal Historian Collection.)

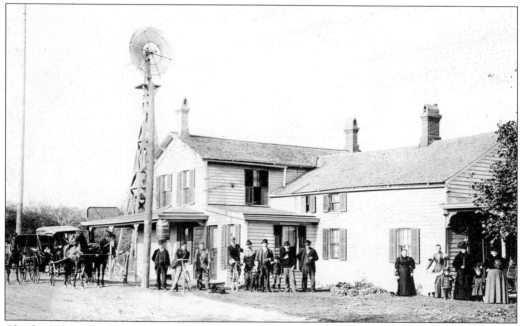

Charles Schreib operated the Schreib Hotel in Twelve Corners from *c.* 1895 to the early 1900s. This view dates from *c.* 1895. The establishment later became the Leary Brothers Hotel. It is hard to imagine the Twelve Corners of today ever looking like this. Guests and employees pose outside, along the dusty road. The windmill was used to create suction to draw water from the well. (Courtesy Brighton Municipal Historian Collection.)

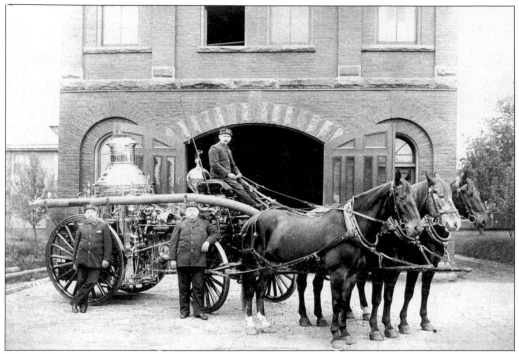

Three firemen pose with their highly polished engine in front of the Engine Company No. 6 firehouse on University Avenue. This image dates from 1907. (Courtesy Rochester Municipal Archives.)

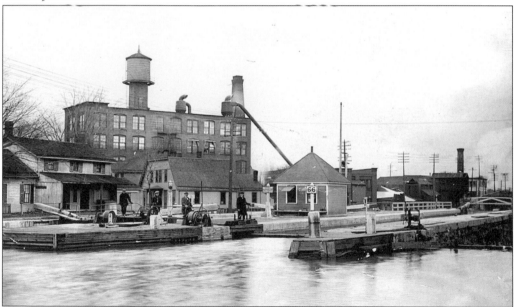

The Erie Canal at Monroe Avenue was a busy place in 1918. Plans were already being drawn to reroute it outside the city limits because of the delays it caused. The waterway that brought the industrial revolution to Rochester had become a nuisance. The subway system would take over sections of the canal's right-of-way. Tracks would eventually run through here, after the drained canal bed was graded. (Courtesy Rochester Public Library Local History Division.)

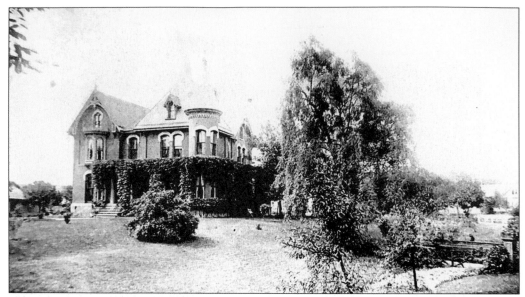

W.W. Chapin and his wife, Elizabeth Lyon Chapin, moved from one of the Third Ward's most distinguished homes to this romantic French chateau–styled home at 1545 East Avenue. It was built across the road from Willow Pond in 1879 for $27,000. The broad lawn and idyllic setting were a favorite attraction to travelers. Elizabeth's heart was still in the Third Ward, however, and the family decided to move back. This photograph was taken between 1886 and 1915, when the Wichmann family owned it. (Courtesy Landmark Society of Western New York.)

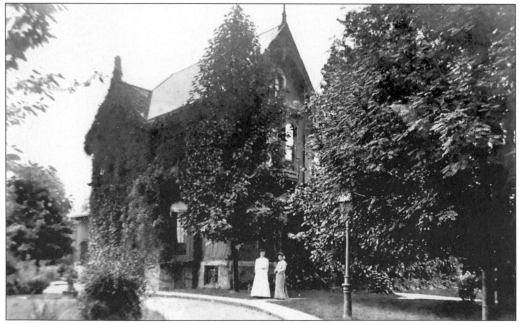

Two women, probably Wichmann family members, stand beside the towering, vine-clad facade of the former Chapin residence. Charles Wichmann was born in Poglitz, Prussia, in 1855. He came to Rochester as a youth and worked for Ellwanger and Barry and then for tailors. In 1875, he began Wichmann and Kallusch, a large tailoring business. (Courtesy Landmark Society of Western New York.)

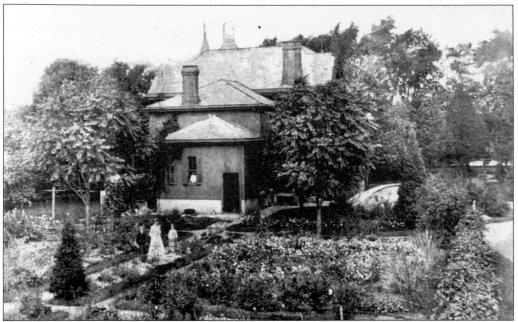

Another Wichmann family view shows the broad gardens behind the house. The avenue has always been endowed with a lush and fragrant environment. (Courtesy Landmark Society of Western New York.)

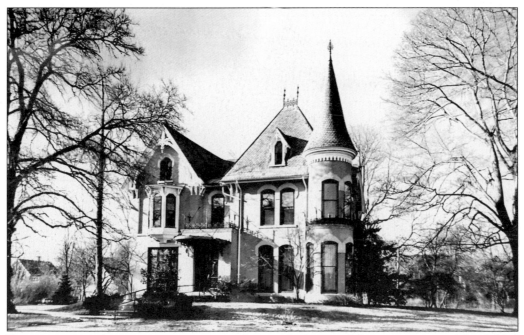

For years, new architects eager to pursue modernism had rejected the romanticism of the Gilded Age. The attraction of pre-1920 designs, however, would prove irresistible. Today, a new generation of artists and architects looks back to these old beauties for inspiration. Fortunately, the Chapin House still graces the avenue. (Photograph by Hans Padelt, courtesy Landmark Society of Western New York.)

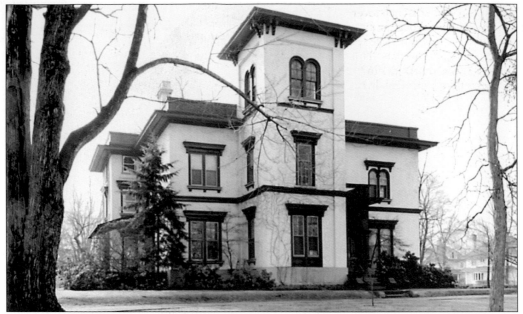

When the four Ryder children moved into the Bates house, their first-day trepidations were lessened by their parents having a pony and gaily painted pony cart waiting for them in the barn. Designated as the Bates-Ryder house, this noted Italian villa was distinct for years because of its pink exterior. A fire in the late 1960s caused severe damage. The owner, Helen Ryder, fortunately decided to restore it to its original grandeur. She then gave it to the Landmark Society of Western New York. This view dates from 1968. (Photograph by Hans Padelt.)

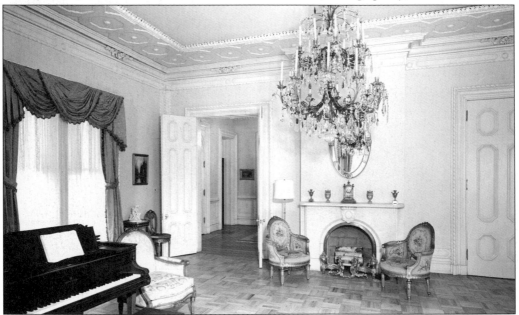

A white-marble fireplace and large chandelier adorn the Bates-Ryder music room. The home has been skillfully portioned into condominiums. By the early 1970s, Helen Ryder was one of the last of the old families left. Georgianna Sibley remained in her house at the opposite end of the street. This photograph was taken in 1967. (Photograph by Hans Padelt.)

The Bates-Ryder entrance foyer and staircase reveal outstanding details of a bygone era. Note the plaster ceiling adornments. This photograph was taken in 1967. (Photograph by Hans Padelt.)

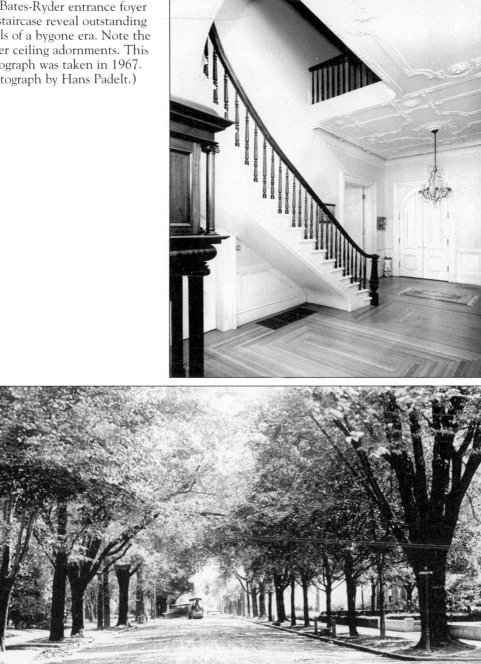

Road equipment works on the macadamized road surface in the Arnold Park area. Note the carriage blocks and hitching posts. In 1911, the road was paved with asphalt, and the last carriage was gone by 1915. Most American grand avenues had their heydays from 1850 to 1920. East Avenue saw another dozen mansions go up through the 1920s and early 1930s, although the grandeur was beginning to fade. In the 1950s, this majestic canopy of elms was hit by the elm tree beetle blight, but the trees survived. East Avenue was narrow for a grand avenue, and that only increased the lushness and intimacy of it. (Courtesy Rochester City Hall Photo Lab.)

The Boynton house, at 16 East Boulevard, was an early work of Frank Lloyd Wright. The "prairie-style" house (built in 1906–1907) was a revolutionary design set among more traditional homes. Despite some residents' uncertainty about the modern styling, it was quickly accepted in a district where architectural innovation was encouraged. Increased traffic on the avenue was causing some residents to seek the solitude of the new fashionable side streets, such as Douglass Road and East Boulevard. Soon, more were being laid out at Sandringham, Ambassador, and Esplanade. The architects were back in business. (Photograph by Hans Padelt.)

The tradition of exceptional craftsmanship continues to this day. Brenda Moss of Brenda Moss Design Concepts and her husband, Lee Moss, built this sumptuous Mediterranean-style residence in 2001–2002. Designed by architect Tim Tyskiewicz to blend into a 1920s-era residential street, it represents a continued commitment to the area. Hand-applied stucco, chimney embellishments, and tiled roofs are among its more distinct features.

126

The Moss residence required the talents of some of Monroe County's finest craftsmen. The interior features marble, granite, and tile from around the world. Exotic woods, superb carpentry, faux finishing, state-of-the-art electronics, and custom metalwork have resulted in a glittering showplace. The entrance hall chandelier can be electronically lowered for maintenance.

We are fortunate that the district is doing well thanks to the hard work of preservation-minded organizations. East End, Park Avenue, and Clothesline festivals draw thousands annually, as do tours, museums, galleries, and theaters. Historic East Avenue resides in our imagination surrounded in a mystique perhaps best captured in this 1880 image. Hoofbeats over the stone-encrusted road are muted under towering elms. Somewhere, there had to be sounds of craftsmen applying their skills to yet another architectural masterwork.

Children look on—those born into a world of pamper and privilege. Sent around America and Europe for educations, they would know other grand avenues—St. Charles Avenue, in New Orleans; Vandeventer Place, in St. Louis; Delaware Avenue, in Buffalo; and France's 275-foot-wide Avenue des Champ-Elysees. They would visit other ambitious Baroque- and Renaissance-inspired boulevards, squares, promenades, and esplanades, but their pioneer avenue with the banal name, East Avenue, was dearest to their hearts. As young adults, they would be pointed toward potential mates within their exclusive circles. Their young families would be entrusted to carry on the cherished traditions of the avenue. Among those would be the quest for personal achievement, philanthropy, and pride in community—traditions common in most families. That the city and county continue to benefit from their labors shows they held those traditions sacred.